IMAGES
of America

WEST WHITELAND
TOWNSHIP

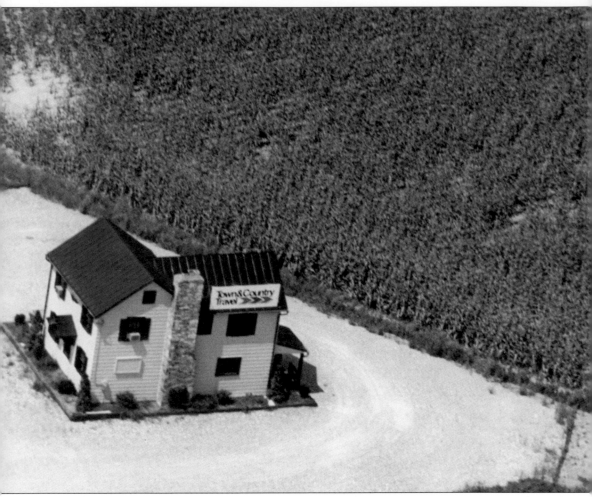

Built in 1880, the Dorsey Ashbridge house is located at the intersection of Pottstown Pike and Waterloo Boulevard. The cornfield is now home to a McDonald's and the Exton Plaza shopping center. West Whiteland Township once had approximately 8,000 acres of open space. Life in the community revolved around farming and knowing the weather could have a great impact on a person's livelihood. Due to the construction of retail centers, housing developments, and office parks, the land is no longer primarily used for farming. The community is thankful for the space that has been preserved as parkland. (Courtesy of West Whiteland Township.)

ON THE COVER: The Exton Dairy Grille was established prior to the well-known Guernsey Cow restaurant. The establishment opened as a retail outlet for Montcalm Farms in 1927. In 1931, Ilario "Larry" and Gladys Polite purchased the property. This photograph was taken in the early 1930s and shows, from left to right, Gladys Polite, Millie "Dolly" Polite (Ilario's sister), Elmer Polite (Ilario's brother), and Ilario Polite. (Courtesy of Sean McGlinchey.)

IMAGES
of America

WEST WHITELAND
TOWNSHIP

Janice Wible Earley

ARCADIA
PUBLISHING

Published by Arcadia Publishing
Charleston, South Carolina

Printed in the United States of America

Library of Congress Control Number: 2014946361

For all general information, please contact Arcadia Publishing:
Telephone 843-853-2070
Fax 843-853-0044
E-mail sales@arcadiapublishing.com
For customer service and orders:
Toll-Free 1-888-313-2665

Visit us on the Internet at www.arcadiapublishing.com

To Diane Sekura Snyder, for her dedication to the preservation of West Whiteland's history and her diligent efforts to save many of West Whiteland Township's historic buildings

CONTENTS

ACKNOWLEDGMENTS

In 1982—Chester County's 300th year—volunteers from the West Whiteland Historical Commission located and researched local buildings thought to have historic significance. Many of them were later placed in the National Register of Historic Places. Additionally, a file was created for all historic resources in West Whiteland Township, and this resource has been used to save many historic buildings. It was also an invaluable resource in the writing of this book. Through the years, the stewards of the West Whiteland Historic Resources have kept the files organized and added information and photographs as they became available. I would like to thank all members—current and past—of the West Whiteland Historical Commission, including Diane Snyder, M.L. Willenbrock, Martha Leigh Wolf, Nancy Carville, Bruce Flannery, Cindy Drager, Gail McCahon, Bobbie Eckman, Mary Kivlin, and township staff member John Weller.

I would also like to acknowledge Sean Moir, who knew that the Battle of the Clouds was lacking formal research. Sean worked to receive a grant that allowed for the creation of the *Battle of the Clouds Technical Report*. Additionally, Gail McCahon generously provided her Richard I. Downing letters and the photographs from the Whitelands Hunt. Tom Jackson and the Newlin family provided the photographs of the Ashbridge-Newlin property, with the coordination of Paul Schneck. Sean McGlinchey provided his photographs and knowledge of the Guernsey Cow restaurant. Lori McDermott and Jim Tate should also be thanked for providing information on the Church Farm School, as should Pamela Powell, my resource at the Chester County Historical Society.

I would also like to thank Linda Calderin for giving me direction and Abby Walker, my acquisitions editor at Arcadia Publishing, for her advice and guidance.

Finally, thanks go to my husband, Sean, for always saying, "Whatever makes you happy," and to my children, Jonathan and Shannon, for listening to my stories about local history.

Unless otherwise noted, all images appear courtesy of West Whiteland Township.

INTRODUCTION

West Whiteland Township's motto is "Pride in Our Past. Pride in Our Progress." In Wales, the word *whitland*, spelled without the *e*, refers to the site of an assembly of churchmen and lawyers. This comes from the fact that, in 930 AD, Whitland, Wales, was the site of the first Welsh Parliament. West Whiteland Township, located in Chester County, Pennsylvania, is part of what is known as the Welsh Tract, set up by William Penn as a self-governing tract of land for Welsh Quakers, thus explaining the name Whiteland.

Quakers from Wales and England as well as Anabaptists (also known as the Mennonites) from Switzerland and Germany were willing to risk their lives by traveling across the Atlantic Ocean for the opportunity to worship freely. The religious persecution that they endured in their home countries ranged from not being permitted to hold public office to being tortured or even put to death. Out of that persecution, three long-established founding families—the Thomas family, the Zook family, and the Jacobs family—left their homelands and sought religious freedom in Pennsylvania.

Native American artifacts have been found in pockets around West Whiteland Township, and the township occasionally places these artifacts on public display. The Whiteland Quakers found peace among the Lenni-Lenape Indians along Valley Creek. The Lenni-Lenape, whose name is translated as "Original People," are known as a peace-loving tribe and are called "ancient ones" by other tribes, as they are considered the most ancient of the northeastern Indian nations. The colonists admired members of the tribe for their mediation skills and for their hospitality. There was even a Lenni-Lenape village named Katamoonchink, meaning "hazelnut grove," near the intersection of Lincoln Highway and Pottstown Pike in Exton. In 1711, Richard Thomas I settled near the village for the protection that it provided him. The Indian village had barking dogs that frightened potentially dangerous animals, like mountain lions and wolves.

The relationship between the settlers and the Lenni-Lenape remained peaceful, but there were occasional issues with other tribes. The Haudenosaunee Confederacy, also known as the Iroquois and, to English colonists before 1722, as the "Five Nations of Indians," had a claim filed against one of its great chiefs by Richard Thomas I. He claimed that the "King of Five Nations of Indians" had taken a cow that was worth £4. The Indian leader had been traveling through Whiteland after discussing a treaty with the governor in Philadelphia.

In 1681, Richard ap Thomas ("ap" means "son of"), from the village of Whitford Garne in northern Wales, purchased 5,000 acres from William Penn. In September 1683, Richard ap Thomas and his 10-year-old son, Richard Thomas I, sailed across the Atlantic Ocean on the *Morning Star*. Shortly after their arrival, Richard ap Thomas died. After 23 years of living in America, Richard Thomas I, who was a carpenter in Merion, finally obtained his father's claim of 5,000 acres. Of the 5,000 acres, 1,869 were in Whiteland. In 1711, Richard Thomas I settled in Whiteland, and the Thomas family continued to reside and prosper in West Whiteland for many generations.

In 1770, Moritz Zug, whose surname was anglicized to Zook, purchased what is now known as the Zook house from William and Elizabeth Owen. The house, which was originally built in 1750,

is located near the Exton Square Mall. Moritz Zug was the grandson of Hans Zug, an Anabaptist minister who was imprisoned in Bern, Switzerland, for 13 years after refusing to baptize his children as Roman Catholics. Once he was released from prison, Hans was exiled from Switzerland. He raised his 12 children in Germany. According to stories, Moritz traveled to America with his brothers in 1742 and was sold into servitude for two years to pay for his passage. He died in West Whiteland Township at the age of 93.

The Jacobs family were originally Quakers who lived in West Whiteland for 186 years. In the 186 years that the family lived in the area, many generations of Jacobses served as public officials. In 1765, Whiteland had divided into the West and East Whiteland Townships, and it was the first year that each Township had to collect their own taxes.

John Jacobs was involved in approving the first year's tax collection in West Whiteland—a sum of three pence. John Jacobs also served as a member of the general assembly from 1762 to 1776, and in 1782, he served as the constable of West Whiteland Township.

The West Whiteland Township logbook, kept from 1765 to 1940, lists all those who served as constable for Whiteland and West Whiteland, and the only dates missing are the years 1777 and 1778. The Revolutionary War's Battle of the Clouds occurred in 1777, so it may have been deemed too risky to list the name of the constable. Or, perhaps, no one was willing to serve as constable during those two years. According to the Pennsylvania Historical and Museum Commission website, "The Pennsylvania Militia was organized under an act of March 7, 1777, which provided for compulsory enrollment by the constables of all able-bodied male whites between the ages of eighteen and fifty-three." The Revolutionary War directly affected West Whiteland Township in other ways as well, as men and women struggled between keeping with religious doctrine and fighting for freedom from English rule. Those who fought would be expelled from the Quaker Friends Society. Eventually, the British plundered many area farms, and the Battle of the Clouds caused many to flee the British encampment. The Thomases' land, located on the west side of the intersection of Lincoln Highway and Pottstown Pike also known as Route 30 and Route 100, was the site of the Continental army general William Maxwell's Light Infantry unit the night before the Battle of the Clouds. Reenactment photographs in the "Battle of the Clouds" chapter were taken at the Brandywine Reenactment on May 17, 2014, at Sandy Hollow Heritage Park.

West Whiteland Township has grown throughout its 250 years, from a quiet farming community to a bustling suburban area. Through the years, some buildings have been demolished, and some have been saved. This book will show some of both, and hopefully, it will help the reader understand why West Whiteland Township has certain features—like the old-fashioned milk cans that serve as barriers at the Exton Square Mall or the silo next to the Walmart at Main Street Exton. The captions and vintage images within will help in sharing the rich history of West Whiteland Township.

One

BATTLE OF THE CLOUDS

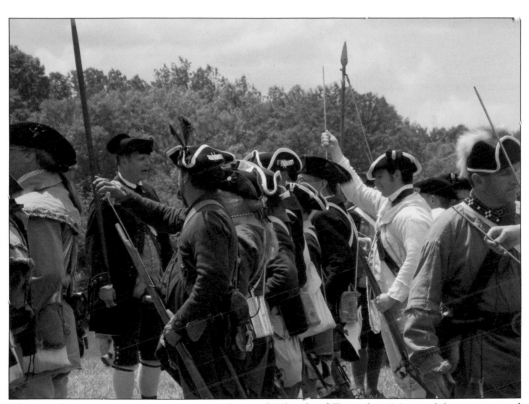

The Revolutionary War affected the residents of Whiteland Township. Many of the men served in the Pennsylvania Militia under Capt. Evan Anderson. Most of the residents were Quakers, Mennonites, or Methodists. If a Quaker man chose to fight, he was often expelled from his meetinghouse, and during the war, Methodists were often Loyalist. Many Whiteland homes were pillaged during the Battle of the Clouds in 1777.

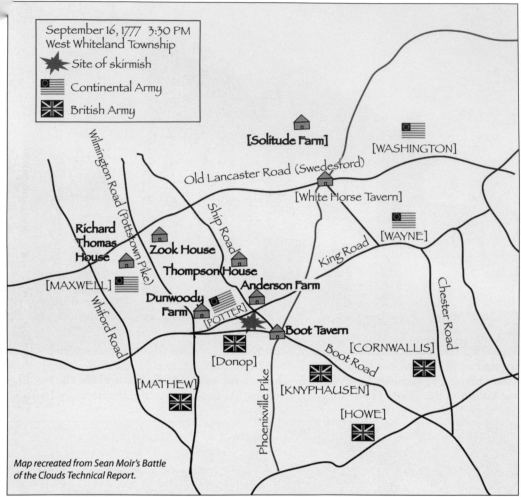

A storm was coming on September 16, 1777, but for some Pennsylvania militiamen, the torrential downpour would not arrive soon enough. The wind was picking up, and storm clouds began rolling in as the Pennsylvania militia, commanded by Brig. Gen. James Potter, marched north on Ship Road, toward the intersection of King Road. Their purpose was to hinder the advancing British army so that the main army, commanded by Gen. George Washington, could travel farther north in order to protect the forges that manufactured their ammunition. At around 3:00 p.m., the Pennsylvania militia found cover in the woods between King Road and Boot Road, where they engaged in a battle with the Jaeger Corps, under the command of Col. Carl von Donop. (Map recreated from one appearing in *Battle of the Clouds Technical Report*.)

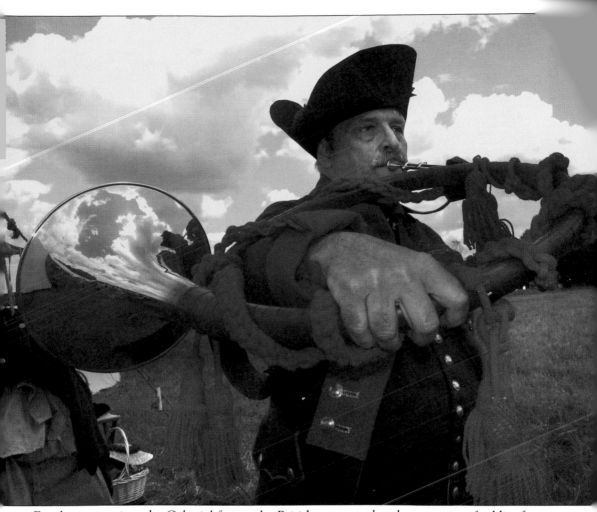

For the war against the Colonial forces, the British army employed a new type of soldier from Germany, called field jaegers. The jaegers were hunters, foresters, and poachers who joined the fight for high pay, and they were considered the elite soldiers of the Hessian division—similar to the modern American ranger. Pictured is a jaeger reenactor, John Grumbine of Hershey, Pennsylvania. Because of the torrential rain at the Battle of the Clouds, muskets on both sides began to misfire, and the jaegers drew their hunting swords. After about two hours of fighting, both the Crown forces and the militia were forced to call off the attack. According to Hessian adjutant general major Baumeiter's account, even the jaegers—charging with their hunting swords—were stopped in their tracks by mud that came up to their calves. The Battle of the Clouds saw five jaegers killed and seven wounded. The Pennsylvania militia suffered between 8 and 11 casualties, and approximately 4 militia officers and 30 soldiers were taken prisoner.

A Hessian jaeger, Capt. Johann von Ewald, provided the following description of the skirmish: "General Knyphausen, who arrived at my company on horseback, ordered me to attack the people in the wood, and the same order was sent to the other companies. I had to cross open ground for several hundred paces before I reached the wood in which the enemy was hiding. During this time I was exposed to enemy fire, which did not seem to be very heavy, since most of the rifles did not fire owing to the heavy rain. I ordered the Jägers to fire and discovered at the second shot that the rifles misfired. But since the attack had to be carried out, I ordered the hunting swords drawn. I reached the wood at top speed and came to close quarters with the enemy, who during the furious attack forgot that he had bayonets and quit the field, whereby the Jägers captured four officers and some thirty men."

According to John Smith Futhey and Gilbert Cope's *The History of Chester County*, "The killed were buried near to the dwelling of Daniel Meredith (1881 reference), and the wounded taken to the house of Daniel Thompson, a short distance north of Meredith's, which was used as a hospital. The house, now torn down, stood immediately in front of the site of the present new house on the Ship road, belonging to Reverend Samuel L. Tennis."

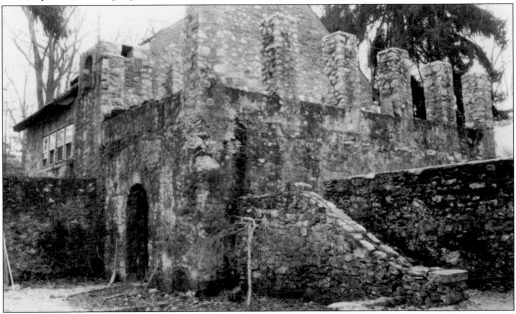

This photograph shows the remains of a stone house, near the site of Colonial resident Daniel Thompson's house on Ship Road. The remains have since collapsed, except for a stone arch that can be seen from Ship Road. Daniel Thompson reported that over £237 of damage was caused by von Donop's troops, which would be roughly $16,000 in the 21st century.

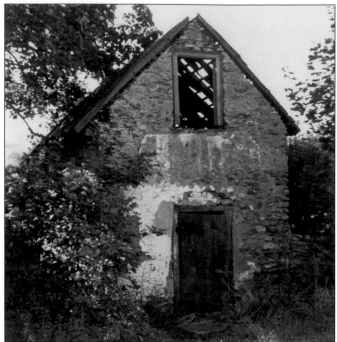

In September 1777, Capt. Evan Anderson (Pennsylvania Militia, 3rd Company, West Whiteland and North Goshen Township) was the owner of the property possibly referred to in Futhey and Cope's *The History of Chester County* as the burial site of the soldiers killed in the Battle of the Clouds. Shown here is the springhouse, which once stood on the property and provided a cool place to store and preserve food.

Some believe that the storm that struck the battle was a hurricane. The roads quickly became extremely difficult to travel, and the British set up camp—which extended from the Goshen Meeting House to King Road. Because of the heavy rainfall, the soldiers set up along the line that they were marching. This quick setup reached from Boot Road up to King Road, and along Ship Road.

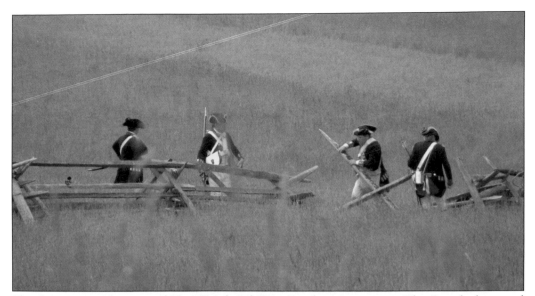

Plundering near the area of Ship Road and King Road was extensive. The British destroyed 19,000 fence rails in West Whiteland Township, burning them as firewood or destroying them to make it easier for an army to travel. Knowing how important the fences were to the farming communities, George Washington forbade his troops from destroying any fences.

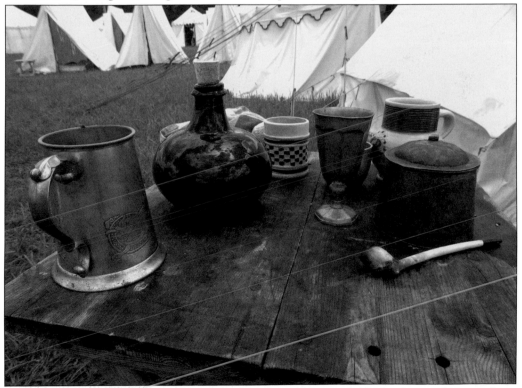

Lists were kept in the hopes that compensation would be available for those colonists whose property had been seized. The colonists never received any reimbursement for the farms that had been plundered, however. West Whiteland suffered property losses of over £950.

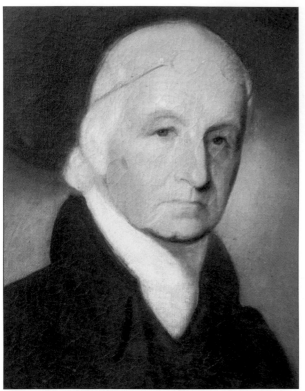

Col. Richard Thomas III served directly under George Washington in the Quartermaster's Corps, 5th Battalion, in 1777. His responsibilities included providing food and supplies for the American troops. After the Revolutionary War, Thomas served in Congress as Chester County's first representative to the nation's capital.

According to family lore, Col. Richard Thomas III was not home during a visit from a small band of pilfering Hessians, but his wife, Thomazine "Downing" Thomas (from Downingtown's first family), was. The Hessians wanted to know the location of the family silver. The soldiers were upset that the family had driven its livestock into the woods and wanted to acquire some items of value.

The soldiers threatened to hang Thomazine Thomas if she did not reveal where the silver was hidden. As a soldier went to retrieve a rope, Thomazine prayed that they would try to hang her from the one wooden peg—and not one of the many iron pegs—that she had in her kitchen, as the wooden peg would not hold her weight. Before the rope was brought back to the kitchen, an order or alarm sent the Hessians on their way. One story says that the silver had been hidden in the well. Thomazine was born in 1754, to Richard Downing and Mary Edge of East Caln, Pennsylvania. The Downing family, who were Quakers, came to America from England in 1754. They established mills along the Brandywine River in the area of East Caln, and eventually, the area around was named Downingtown. (The photograph was taken at the Southery Log House, built around 1744, in Bethel Township.)

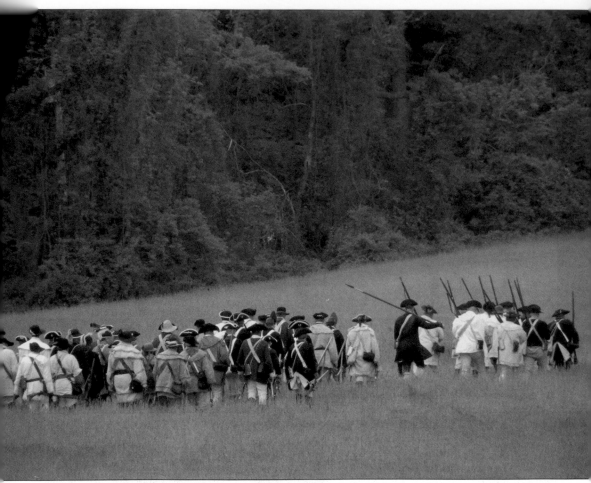

As evening approached, the army reformed along Swedesford Road, as far west as today's Exton Park. With no sign of the British advancing, Washington commanded the main army to Yellow Springs, while Generals Maxwell and Potter moved through the thick mud along Lancaster Road protecting the baggage train as it moved to Valley Forge. On September 17, 1777, British captain John Montresor, of the Corps of Engineers, wrote, "The rain and wind continued at N. E. but not so incessant, the roads became very heavy, and the lowlands overflowed. There being but few houses and barns our troops suffered much from the weather." Unaware that Washington had slipped out of the Great Valley overnight, Montresor continued, "Several people returned from the rebels with various accounts, but in general agree that Washington with the gros [sic] of the Rebel army is now on the Lancaster Road between the White Horse and Downing Town, a homely Tavern on the road to Swedesford with . . . 37 pieces of Cannon."

Two

LETTERS FROM RICHARD I. DOWNING

This chapter includes excerpts from letters written by Richard I. Downing while he lived in Colebrook Manor in the mid-1800s. Downing was the great-grandson of Thomas Downing—the namesake of Downingtown—a well-educated Quaker and the son of Joseph and Elizabeth Webster Downing. Gail McCahon very graciously loaned the letters that have been transcribed in this book. (Courtesy of Gail McCahon.)

Richard and Susan Downing had six children. Tragedy struck the family in 1851 when three of their sons—Joseph (14), Henry (8), and Richard (4)—died of typhoid fever within three weeks of one another. According to Lewis Downing, the boys contracted the disease from playing in an area where a pond was being dug. At the time, the family was living at its old homestead, at 601 Lincoln Highway. Richard I. Downing wrote many of the letters in this chapter to his daughter Sallie while she was living at the Pittsfield Young Ladies' Institute—a boarding school in Pittsfield, Massachusetts. The letters show a loving father and husband, who was close to his cousins in Hartford County, Maryland. The Civil War caused a strain in Richard's relationship with his cousins, as some of his relatives favored the rebellion. Richard Downing built a large white barn, a carriage house, and a blacksmith shop on his property, which is now known as Colebrook Manor. Today, the McCahon family uses the latter two buildings in its veterinary clinic. (Courtesy of Tom Jackson/the Newlin family.)

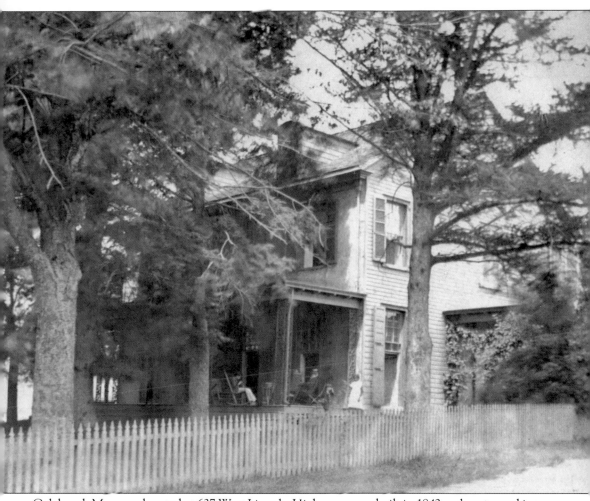

Colebrook Manor—located at 637 West Lincoln Highway—was built in 1842 and converted into a "manor" by Richard I. Downing and his wife, Susan Havard Miller Downing, in 1854. In a July 11, 1854, letter to his daughter Sallie, Richard writes, "I am unable to answer any of your inquiries except to the one relative to the building, and that one I cannot answer very satisfactorily. The carpenters are getting on very slow. They will not be ready for the plastering for two weeks yet, and as to the stonecutter, he is doing worse than nothing. He is the only one I can get and is a first rate workman but is two thirds of his time off drinking I do not think we will be ready for the painters and papers before November." This photograph was taken in 1878 and shows Richard on the porch with his grandson Charlie Pinkerton, John Pinkerton, and a nurse. (Courtesy of Gail McCahon.)

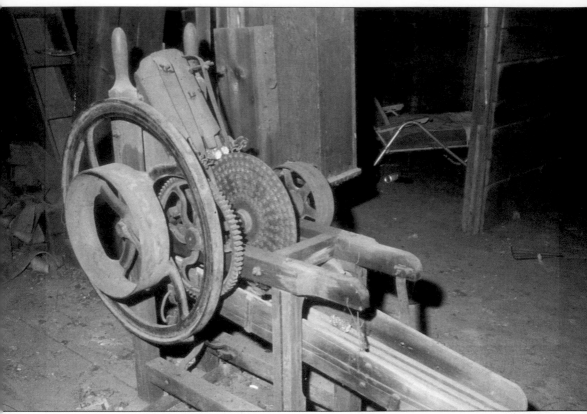

A letter from J. Havard Downing, age nine, to his sister Sallie Downing, November 16, 1854, states: "Dear sister, I received your letter last week. It has been pretty cold here this week. I have caught 20 rabbits this year. I sent cousin Mary one and I sent Sam two or three. I would send you one if I could. I have seven traps. When I take the cows out I look at them. The weather has been very wet until this week. We are done husking corn. Father is working hard at stacking fodder. I must go for the cows tonight so good by. Your affectionate brother, J. H. Downing." This photograph shows a corn husker, also known as a sheller, which may have been used by Havard to husk corn to make feed for the animals. The corn husker was invented in 1815, but many farmers were still using handheld cornhusking pegs into the mid-1800s.

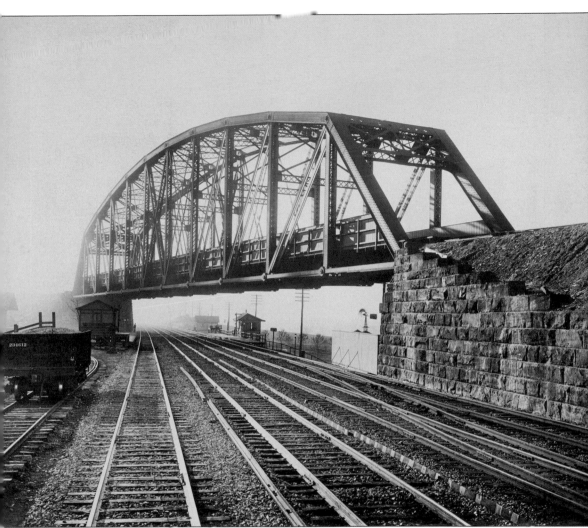

In a letter to his first cousin William Webster of Hartford County, Maryland, January 15, 1857, Richard I. Downing writes: "Tell me also upon what evening you expect to arrive here. Our train leaves the corner of 11th and Market Street by way of the Pennsylvania Railroad at 2:30 another the corner of ninth and green at 3 o'clock by way of Norristown and Chester Valley Railroad. I would recommend the former but either will do. In either case, get out at the Oakland station they are on the same county road and are the nearest stations to us on both roads. With love to all including Aunt Davis. I am most sincerely yours, R.I. Downing." The Oakland station was built from stone gathered at the abundant marble quarries in the area around Oakland Village. In 1881, the tracks were straightened, which resulted in the station being too far from the rails. In 1907, the Whitford Station, shown here beyond the Whitford Bridge, replaced the Oakland station. (Photograph by William H. Rau, courtesy of the J. Paul Getty Museum, Los Angeles.)

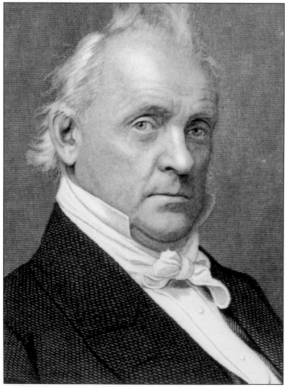

This excerpt from a letter dated September 29, 1856, states: "They have a Fremont flag and pole up at White's shop and large flags strung across the pike at Shelmire's Mill. We are going to Media on Thursday in 2-four horse teams to hear Anson Burlingame speak and will raise a pole at Zooks [pictured] next week. I was at a meeting last night where we formed a club for our Township."

An excerpt from a letter dated October 15, 1856, reads: "Tomorrow comes off our state elections we have been preparing for the contest and hope to succeed but as the [James] Buchanan party are fully prepared to cheat to a very great extent we cannot foresee the event. They had added thousands to the list of new assessments which we all think are important votes and if so will tell against us fearfully. Yet notwithstanding which I think we will succeed." Buchanan is pictured at left. (Courtesy of the Victoria Heilshorn Studio, Defiance, Ohio.)

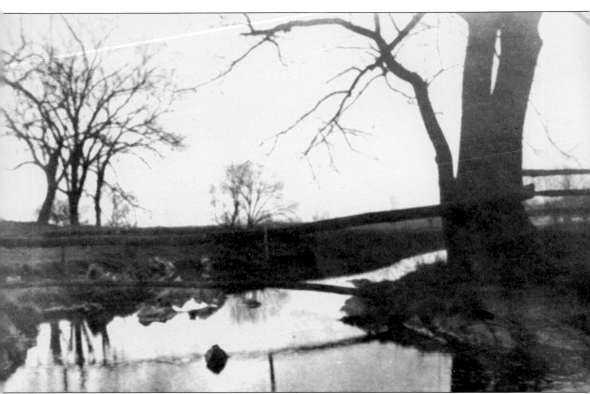

These excerpts come from letters written to Richard's cousin William Webster. The letter dated November 1856 includes: "I would have given anything to have had my dear daughters with me last evening to help entertain the guests. I have been very busy and cousin Mary was kind enough to come for two days and assist me." The one from December 1856 reads: "I have a notion of exploring some of those tributaries [Colebrook Run] I think if anything should result from search it will be lead instead of the pewter. I would greatly prefer finding a large deposit of iron ore here as it is becoming more valuable here every year. I had a gentleman to see me this week, who wish to lease my land for the privilege of mining. As an evidence of its value, a lot of 40 acres, which the party offered a few years ago for $4,000 brought a few days since $15,000 on account of the ore it may contain." By 1883, an atlas showed that the Roberts property, directly east of Richard's farm, was the site of a large effort to mine iron ore.

An excerpt from a letter dated March 10, 1856, states: "And now I am sorry to say I have a less pleasant thing to discourse upon with you. I do not like to scold you yet I find it absolutely necessary to take you to task. Since my return home I find through mother that you went out to Colonel Thomas' and Mr. Jacobs' on two of the coldest nights of the winter dressed in open-worked cotton stockings and slippers, after having worn woolen stockings and lined cloth boots all winter. Now Sallie, I think it really wicked in anyone possessing ordinary understanding to tamper in such a manner with their health, besides running counter to the known wishes of both parents, but in you how much greater the sin, because you profess to be a follower of Christ who command you to honor 'thy father and thy mother'. What will it profit you or I if after years of task at school and absence from home and us you should be carried off by consumption, as you most assuredly will if you continue." (Art by Constantin Guys, courtesy of the J. Paul Getty Museum.)

In an excerpt from a letter dated October 22, 1857, Richard writes: "Billy, what did you think of the 'old keystone' the morning after our election. If we are all abolitionist as the Union and other papers persist in calling us there is a pretty good number of us in Pennsylvania. I was perfectly astounded at the result myself only having thought of and worked for the reelection of our brave congressman John Hickman." Pictured here, a young boy shows off his patriotism.

This excerpt from a letter to Lizzie Downing, dated December 30, 1857, states: "Mr. John Roberts has just left after inviting us all to a tea tomorrow evening. And now while I am writing to you Sallie and Hav are reading their Christmas books while mother is drumming upon the old piano. We have only this week moved out of the library although we have had a fire in the furnace since the first of December."

In this excerpt from a letter dated January 19, 1857, Richard I. Downing writes to his daughter Sallie: "This has been a day of shoveling snow. I took George and the two-horse sleigh this afternoon and went to Thomas' mill for flour. We had to turn out into the fields three times between here and mill. The snow drifted all across the pike as high as the fences for a half a mile at a stretch. It has drifted more than any snow since 1831. No cars have been today and from the appearance of the railroad will not for several days. The party at the Colonels will not come off. Emily thinks she will wait now until you come home. After the roads are broken what a jingling of bells there will be as we have not had any sleighing this winter." (Art by Pieter Molijn, courtesy of the J. Paul Getty Museum, Los Angeles.)

In an excerpt from a letter dated January 23, 1957, Richard writes: "I have to attend court which may detain me from the wedding but if it should I will have George to drive your mother and cousin Mary who wishes to go in style with a driver. I hope to go myself as Mary is one of my special favorites, besides I enjoy going to weddings."

In this letter, dated August 8, 1858, Richard writes: "A good many visitors are now staying in the valley and the usual round of invitations are about coming off, but not to the same extent as formerly. The times has an effect even on our rural population and will not allow of the extravagances of the few last years. I think good will result from the financial embarrassments of the times and leave us all to live more like a farming community than we have been doing." (Courtesy of Tom Jackson/the Newlin family.)

BAMFORTH & CO

(HEARTIEST CONGRATULATIONS.)

May your troubles be little ones.

ENERAL ROBERT E. LEE AND STAFF, GETTYSBURG, PA.

This excerpt from a letter dated July 27, 1863, relates: "Before my cold was well, Lee was threatening Harrisburg and I was foolish enough to go with a militia for its defense, while there I was taken sick and returned home, consequently have been good for nothing all harvest. Ever since the Battle of Gettysburg I have looked over papers to see some account of Ned's regiment, but I have not been successful and presume he was not in the fight. I feel anxious to hear from him and will thank you to inform me of his doings and of his health. If you know anything about Jim Walters please let me know as I have heard it reported that he had been killed—I did not place any reliance on that report because it was said he belonged to a rebel Maryland Regiment which I did not think was the fact." (Postcard published by Louis Kaufmann & Sons, Baltimore, Maryland.)

Three

COUNTRY MANOR HOUSES AND THEIR STORIES

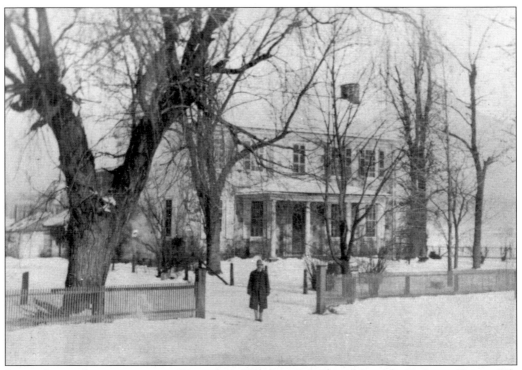

Located near the intersection of Pottstown Pike (Route 100) and Lincoln Highway (Route 30), Whitford Lodge and Whitford Hall sit in front of the Whiteland Towne Center. Col. Richard Thomas III built Whitford Hall (145 West Lincoln Highway) and Whitford Lodge (179 West Lincoln Highway) in the late 1700s. He named the manor houses for Whitford Garne, Wales—the village where his grandfather was born.

In 1826, Templin R. Thomas was born at Whitford Hall. He eventually became the owner of Thomas Mill, Whitford Lodge, and Whitford Hall. Thomas served in the Civil War, on the Union side. There is a secret room in the Whitford Hall cellar that, allegedly, was used to shelter runaway slaves.

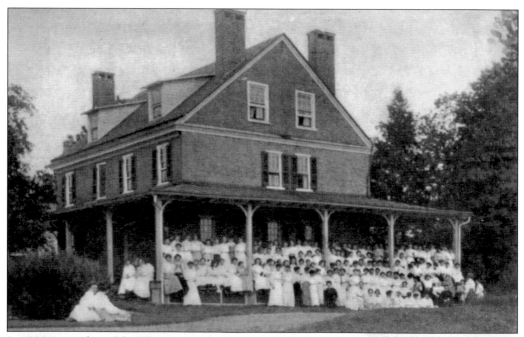

In 1900, a member of the Thomas family, Reverend Bull, donated the use of Whitford Lodge to the Association for Women Workers. The Association of Women Workers was a turn-of-the-century organization focused on strengthening women's ability to enter the workforce.

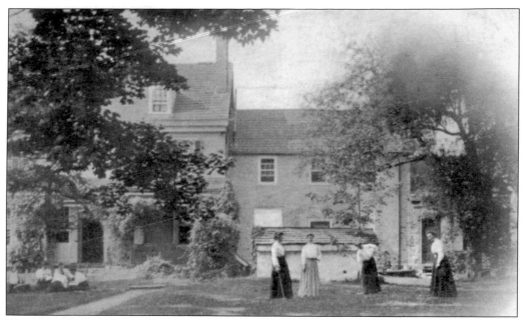

Women working in factories were given poor pay, which did not leave anything extra for vacations. For 28 years, the Association of Women Workers used Whitford Lodge as an inexpensive vacation home for these women and girls. In 1902, a stay cost $3 a week.

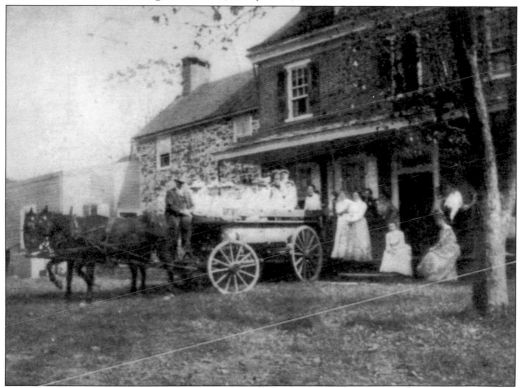

The lodge had a capacity of 28 women, and in 1913, a bathhouse and swimming pool were added. The ladies would travel to Downingtown and Coatesville via buggy to shop and buy ice cream.

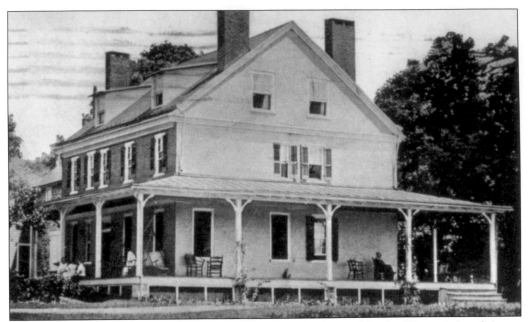

During World War I, the porch and carriage house were also used by the Women's Land Army. This group was formed in 1918, when it became apparent that the war in Europe had created a local shortage of agricultural goods and farmworkers.

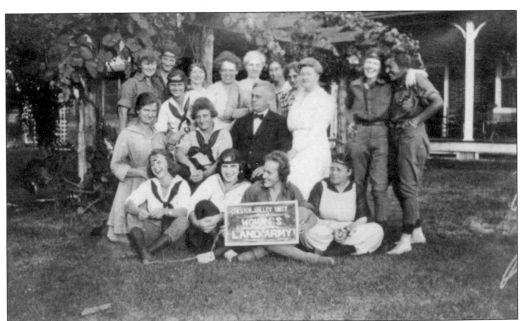

For his article "Quality of Life Enhanced by Adaptability" (*Spartanburg Herald-Journal*, July 16, 1990), Darrell Sifford interviewed Emily Mudd about her time in the Women's Land Army. She says, "I got 18 Vassar girls to sign up with me for the Women's Land Army. We got our khaki bloomers and blouses and came to the country outside Philadelphia. We lived on the porch of an estate, slept on Army cots. We pitched hay, weeded corn, picked vegetables."

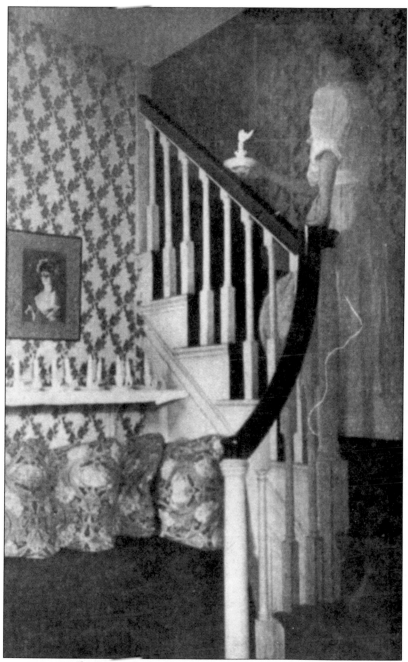

In another portion of Sifford's article, Emily Mudd recalls, "Trucks took us out to the fields every morning. . . . It was a boiling summer day, and we ran out of drinking water. We went to the back door of the estate and asked for water. They had Irish maids there—they looked at us—women in khaki bloomers—and said 'For the likes of you, we have nothing.' We were so thirsty, and we thought maybe we could find an old well somewhere. That's exactly what they found—an old well filled with green water. No one knew anything about health risks, so we put canteens down into the green water and drank." Not long after that, Emily came down with typhoid fever and spent the next three months in a hospital.

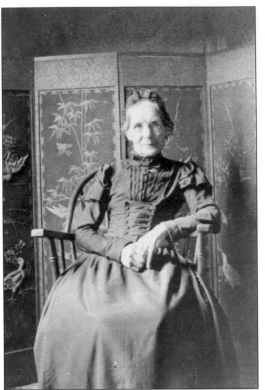

In 1930, Rev. William L. Bull oversaw the transfer of ownership of Whitford Lodge to Chester County, for use as a center for civic, recreational, and social purposes. During the first year of the county program, the board had financial obstacles caused by the Depression. To meet the county's financial needs, subscriptions, dinners, teas, and luncheons were held at the lodge. This woman pictured inside the Whitford Lodge in the late 1800s is most likely a relative of the Reverend Bull.

As a civic center, the lodge and carriage house were used by a drama school, painting classes, the Chester Valley Nurse Association, and other groups. It is worth noting that Martha Gibbons Thomas started the local chapter of the League of Women Voters in the lodge and that the lodge was—in the 1930s—the first home to the Chester County Library. In this photograph from the late 1800s, the woman pictured on the porch of the Whitford Lodge is most likely a relative of Martha Thomas.

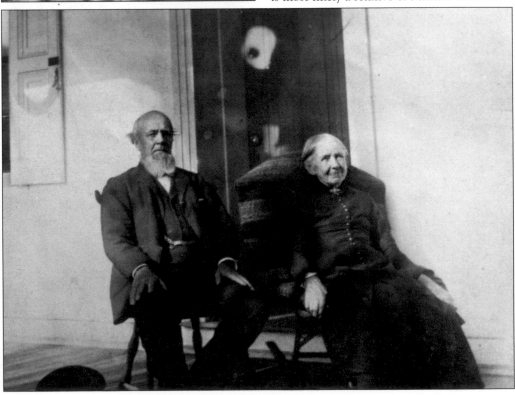

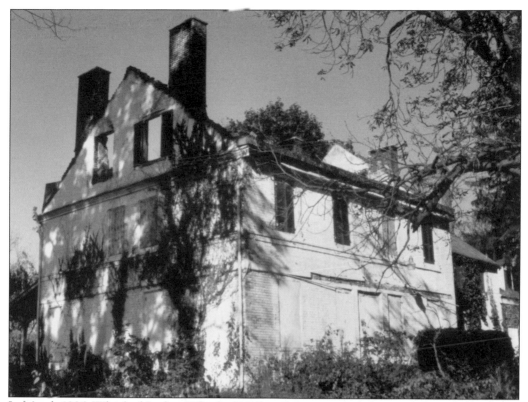

In March 1986, Whitford Lodge, Whitford Hall, and the carriage house were damaged by arson. The carriage house could not be saved, but in 1987, developer Bernard Hankin purchased the lodge and the surrounding 4.5 acres for $300,000. The lodge (pictured) and hall were rebuilt and are now used as office space.

In this photograph, Charles Thomas stands in front of the Fairview manor house, located on North Whitford Road. Fairview was a wedding gift for Charles Thomas from his father, George Thomas, MD. Charles was an overseer on a 245-acre dairy farm, as well as a hunter and horticulturist.

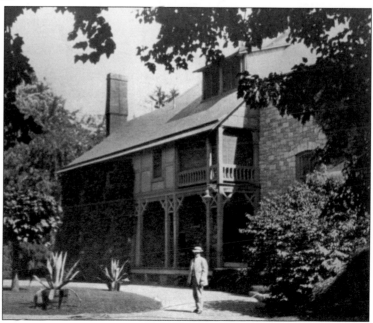

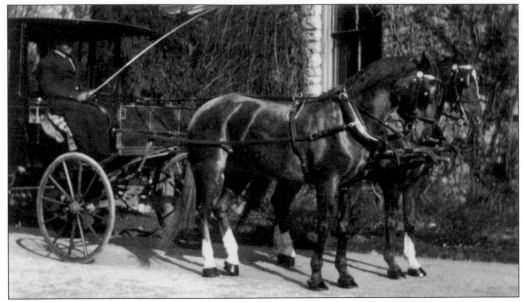

In a February 12, 1989, interview with Kay Oliver of the *Suburban Advertiser*, Barbara Burdick says of her family, "In 1878, my grandfather [Charles Townsend Thomas] married Isabelle Gibbons, a descendant of the Lukens family, and instead of a honeymoon, they drove by buggy from Coatesville to their beautiful new home. The steps leading to the porch were not yet finished, so the young groom very gallantly carried his bride in his arms from the carriage over the threshold, even without the aid of the steps."

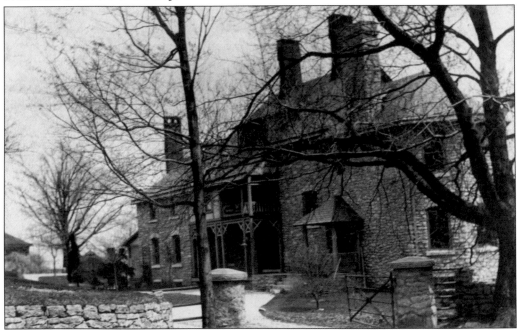

Fairview is located on Whitford Road. While reminiscing about her grandfather's home, Barbara Burdick said, "I can remember sitting on Fairview's porch on a summer evening, looking out over the valley. There would be only one light in view in the whole area, and that was from one wretched little gas station at the intersection of Route 30 and 100."

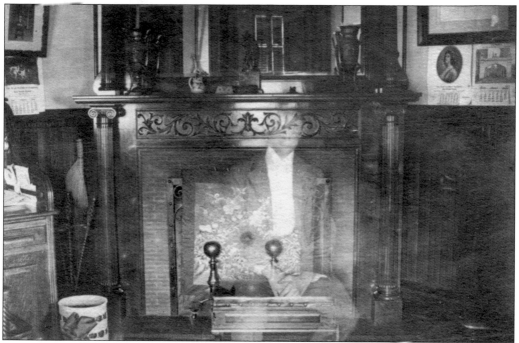

Looking closely at this photograph, it is possible to see the faint image of a man who may be Charles Townsend Thomas. Readers may come to their own conclusions as to how the man's image became so faded, while the rest of the den looks so clear. Fairview was built between 1877 and 1878.

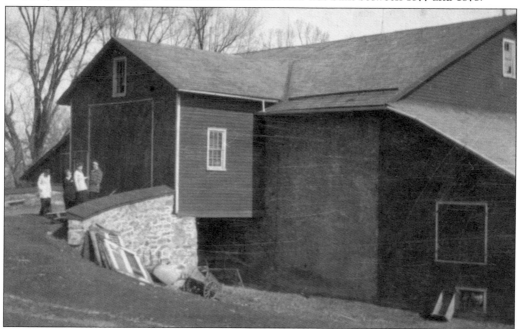

According to Barbara Burdick, "My grandfather was a gentleman farmer, very involved with his horses and dogs. There is still an animal graveyard at Fairview with marble headstones. After a bit, thinking the marble a bit ostentatious, my grandfather simply made cement markers and carved in the appropriate names and dates himself."

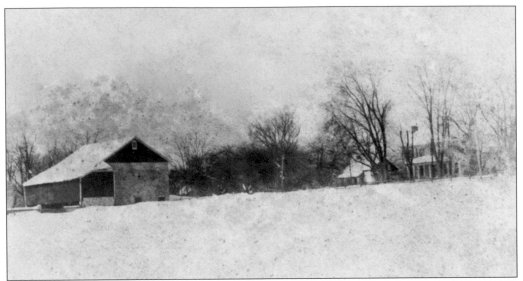

There was a time when Lancaster Pike was just a gravel road. In an interview, Barbara Burdick recalls, "There was a night watchman, kind of a 'town watch' type person who patrolled the valley every night on horseback. My mother used to set sandwiches and coffee out on the porch railing for him. She thought he had such a lonely job."

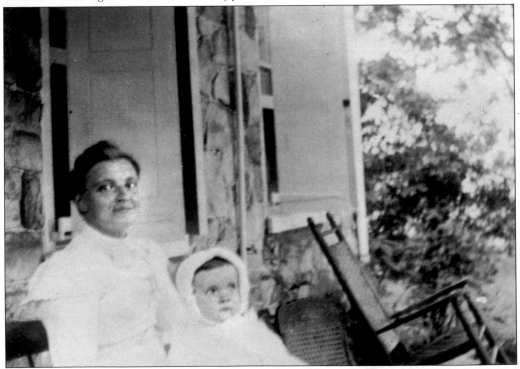

A need for servants came with the owning of a manor house. In this photograph, an unidentified woman and child sit on the porch of Whitford Hall. The woman may be a Thomas relative or friend, or possibly the family's nurse. In the 19th and early 20th centuries, a nanny was referred to as a nurse. If the nurse had an assistant, she would be known as a nursemaid. The name was derived from working in the nursery.

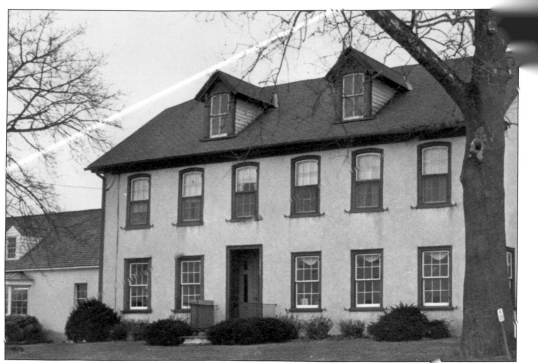

Located at 463 West Lincoln Highway, Ball and Ball Reproduction Hardware was originally a tenant house for Hunt Downing's farm, which was built around 1830. In the 1920s, the building was known as the White House Inn. The structure has been used as the storefront for Ball and Ball since 1943.

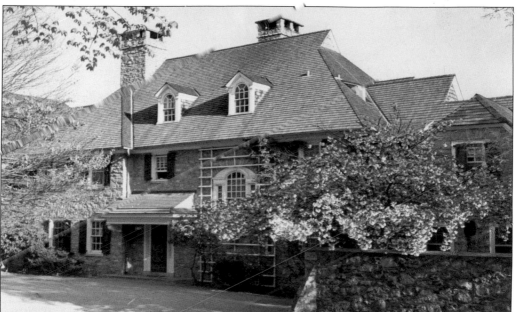

In 1908, George B. Page designed Chesteridge Mansion for Benjamin Rush. In 1948, the Rush family sold most of the property to the Devereux Foundation. The Devereux Foundation purchased the property to make its first licensed psychiatric facility for children in Pennsylvania.

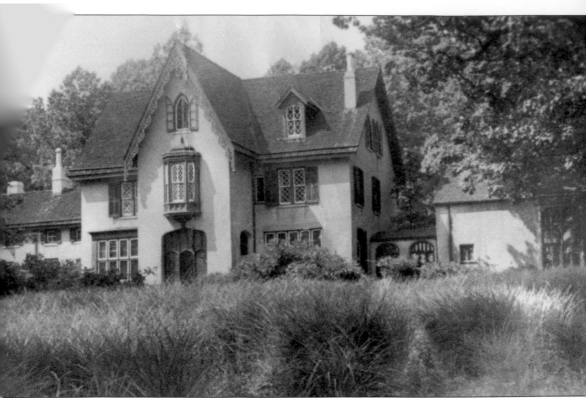

Pictured here around 1920 is Kates Mansion. Hewson Cox built the mansion—now known as Soledad—in 1854. Cox based the plans of the house on *American Country Villas*, a book published by Andrew Jackson Downing in 1848. The mansion remained in the Cox family until 1892, when it was abandoned until Clarence Sears Kates's 1904 purchase of the property. Kates hired Milton Medary to direct the restoration—a project that took two years to complete. Kates, a lawyer, agricultural pioneer, philanthropist, and founding member of the Church Farm School, lived in the mansion until his death in 1922. For 20 years, the Church Farm School used the mansion as a dormitory. Kates Mansion was then left vacant for 18 years, until the present owners, Mr. and Mrs. Hollenshead, renovated the house and created some of the most stunning formal gardens on the East Coast. (Courtesy of Lucille Kates Beale.)

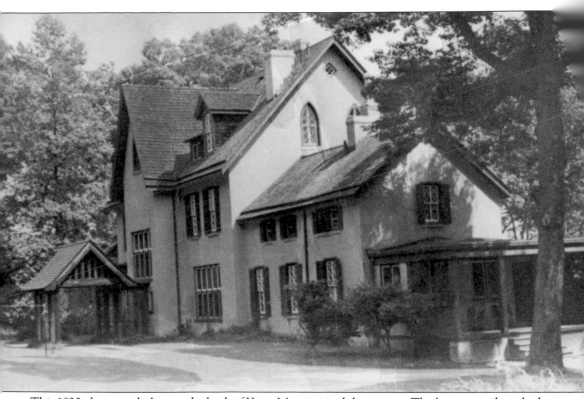

This 1920 photograph depicts the back of Kates Mansion and the portico. The location is described in a newspaper article from August 20, 1904: "On the cool shady portico of a Chester Valley mansion yesterday afternoon sat a most interesting quartet of men, all discussing the subject of good roads and good farming. Not in all Chester County, perhaps was there a more earnest company, as the conversation went on, and it was shown how they agreed. The central figure in the group was the host, Mr. Clarence S. Kates, a handsome young man of smooth face and athletic build; on his right was his next door neighbor, Mr. Robert E. Ross, of Chester, a prominent business man, and on his left was Congressman Thomas S. Butler. Next to Mr. Butler was Reverend Mr. Dietrich, the famous Montgomery county farmer, who has been persuaded to come over to Chester County to take charge of Mr. Kates' farm." (Courtesy of Lucille Kates Beale.)

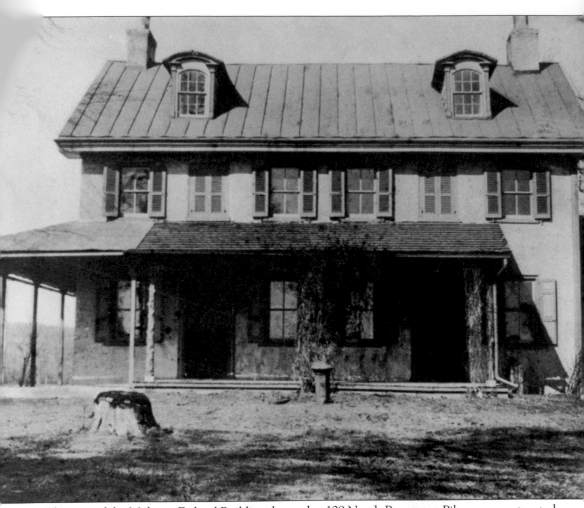

The core of the Malvern Federal Building, located at 109 North Pottstown Pike, was constructed in 1810 by Hannah (Trimble) Jacobs and her husband, Isaac Jacobs, after Hannah inherited the property from her father, William Trimble. Between 1810 and 1964 before the building became the Malvern Federal Savings and Loan office, the structure served as a home for farmers, an office for local doctors, and an office for the Whiteland Silica Company. During the height of production, the Whiteland Silica Company shipped on average of 20 tons of sand a day to Europe to be used in the creation of cement. The sand was described as the best in the state of Pennsylvania.

Four

BEFORE MAIN STREET EXTON

This large manor house can be found at Main Street Exton, off Commerce Drive. The site of the house is allegedly the location of the first permanent homestead in the township, which was built by Richard and Grace Thomas in 1749. The original home stood until 1895. Richard Ashbridge, the grandson of Richard Thomas II, built this house (shown in 1845) near the original homesite. (Courtesy of Tom Jackson/Newlin family.)

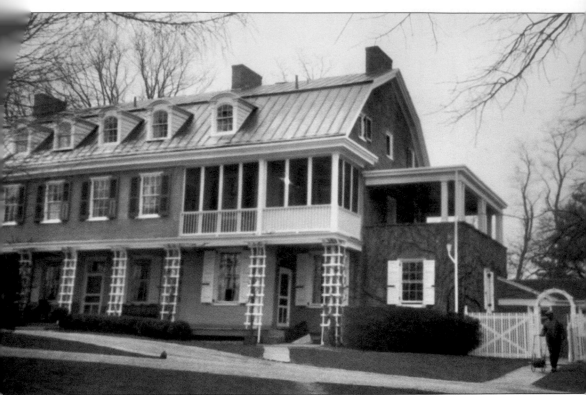

Richard M. Newlin, a Philadelphia banker, purchased the estate on March 31, 1914, for $24,000 and began major renovations on the vernacular Greek Revival manor house. Renowned architects Charles Jackson McIlvain and Spencer Roberts developed the designs for this renovation. According to a 1914 newspaper article, "The residence was built more than 100 years ago and has many unique features. One of these is a bathroom built when the house was built, with an arrangement in the wall for heating water for the bathtub similar to a Dutch oven." Several features—lattice around the existing porch, dormer windows, a minor extension off the kitchen, and the latest sanitary conveniences—were added, but the core of the house was undisturbed. A stone tenant house and a frame-and-stone garage were also added during the renovation. Richard was married to Alice E. Eisenbrey, and they had resided in Haverford and purchased Indian Run Farm as a summer residence. (Courtesy of Tom Jackson/the Newlin family.)

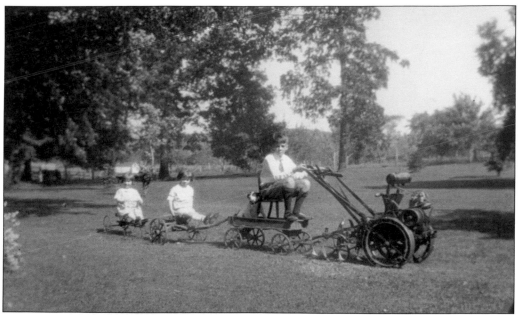

This c. 1924 photograph shows H. Kenton "Buz" Newlin serving as engineer of an ersatz train while his twin niece and nephew, Gin and Jack, ride behind. Even their dog is in on the action. Buz belonged to the Lionville, Goshen, and Fame Fire Companies. He also served on the West Whiteland Board of Supervisors for two terms, before resigning to enlist in the Navy. Buz was a Master Mason and a member of many community organizations. (Courtesy of Tom Jackson/ the Newlin family.)

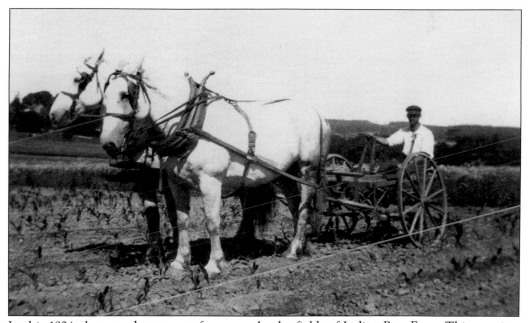

In this 1924 photograph, a tenant farmer works the fields of Indian Run Farm. This area is a shopping complex today, but a replica grain silo between Walmart and Sam's Club was added in order to pay tribute to the past. (Courtesy of Tom Jackson/the Newlin family.)

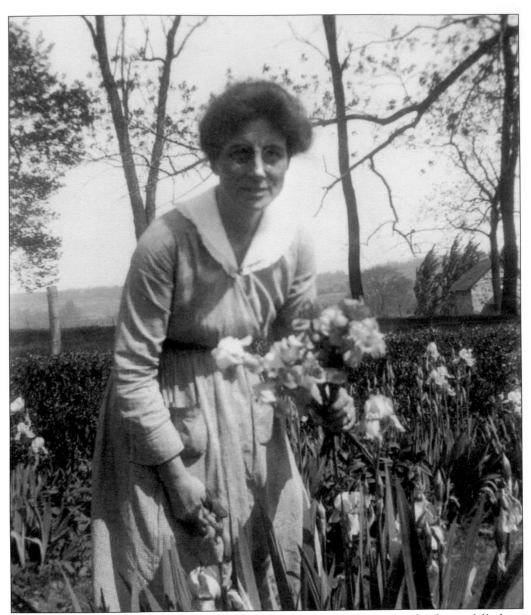

This c. 1921 photograph shows Alice Newlin cutting flowers in the family's beautifully kept garden. After her death, there was some dispute as to the state of the land, as illustrated by this transcript from the Common Pleas Court of Chester County, Pennsylvania, August 5, 1963: "Decedent [Alice Edith Newlin] at the time of her death [September 7, 1954] was the record owner of a tract of land known as 'Indian Run Farm,' at or near Exton, in the Township of West Whiteland, Chester County, containing 84 acres plus, upon which there were existing a [two and a half] story stone mansion, 3 apartments, 18 rooms and 3 baths, a stone and frame barn, 3-car stone garage, and also a single one and a half story tenant house containing 6 rooms and bath. On September 2, 1954, five days before the death of Alice Edith Newlin, the Commonwealth of Pennsylvania, acting by and through its Department of Highways, appropriated a portion of Indian Run Farm for the widening of Route 100, a state highway." (Courtesy of Tom Jackson/ the Newlin family.)

On August 10, 1917, some four years before these c. 1921 photographs were taken on the Indian Run Farm, the following appeared in the *Reading Eagle*: "Chester County Boy Dies From Wound. West Chester: A cablegram to Richard M. Newlin, who resides at the Indian Run Farm, near Whiteland, brings the sad news that his eldest son, John Verplank Newlin, a member of the American field service, which left here about two months ago, died in a base hospital August 5, as the result of a wound by a bursting shell. He was 20 years of age." The Newlin children consisted of John, Edith, Margaret, Richard, Harrison, Alice, and H. Kenton Newlin. The estate, upon which the children could run free, consisted of 84 acres. (Both, courtesy of Tom Jackson/the Newlin family.)

The boy in this 1920s photograph, taken on the porch of the manor house, appears to be saying, "No one gets past me." In 1924, the League of Nations adopted the Geneva Declaration, a document that recognized—for the first time—the rights of children and the responsibility of adults toward children. (Courtesy of Tom Jackson/the Newlin family.)

Alice Newlin is shown here wearing a beautiful fur coat. On September 28, 1928, Richard and Alice Newlin threw a party at Indian Run Farm in honor of Mr. and Mrs. Richard Shipley Newlin—their son and his wife. The 140 people who attended were served assorted sandwiches, Sauter's ice cream, café frappe, frozen cherries, assorted cakes, hot tea, and hot chocolate. (Courtesy of Tom Jackson/the Newlin family.)

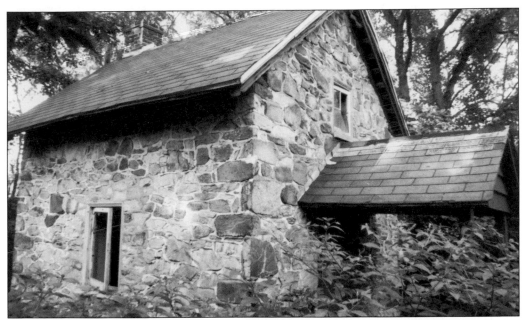

If the datestone of 1707 is accurate it would make the Woodcutter's Cottage the oldest structure in West Whiteland Township and one of the oldest in Chester County. Located in the Main Street Exton shopping area, this structure was originally part of the estate of Richard and Grace Thomas and eventually became part of the Ashbridge/Newlin property.

This picture shows the inside of the Woodcutter's Cottage. The structure was built using fieldstone and consists of one story and a sleeping loft. This small building served as more than just a woodcutter's cottage over its 300 years of existence; it was a smokehouse and a playhouse, and Buz Newlin would catch the train from the cottage to go to school in Haverford. Today, the Woodcutter's Cottage is positioned along part of Chester County's Rails to Trails pathway.

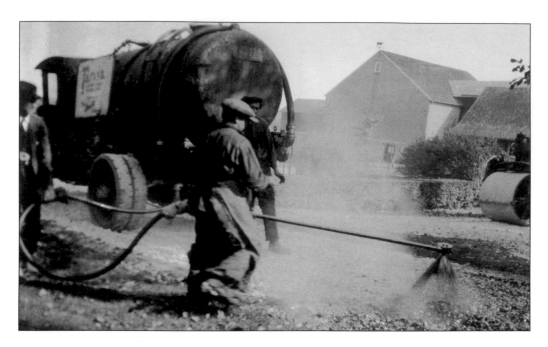

These c. 1924 photographs show employees of the Tarvia Company at work on the Indian Run Farm. In the 1920s, the company was known for paving roads, so much so that Dr. Robert Grise wrote an article about it in 1991. He describes the material, saying, "Tarvia, a soft tar from the Southwest, was widely used as a weatherproof road surface in the first half of this century. It had a consistency somewhere between that of crude oil and asphalt when heated. When it was spread on the road and covered with sand or crushed rock, it made a fairly hard surface." The material was applied as a high-powered spray, blown from a truck. (Both, courtesy of Tom Jackson/the Newlin family.)

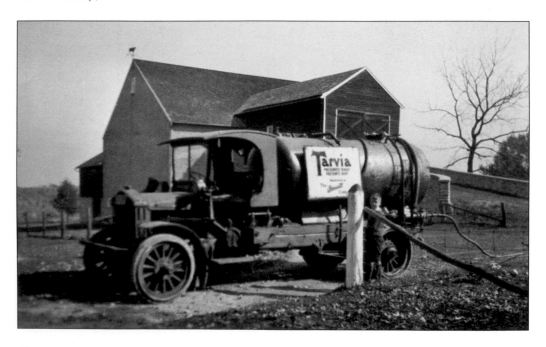

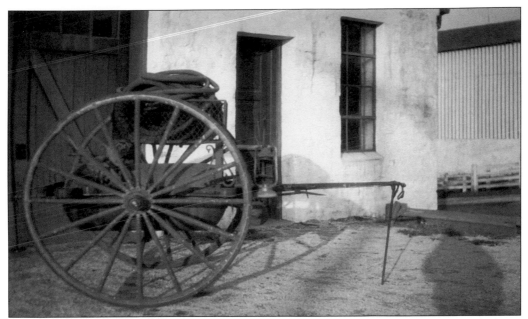

Fires were a major problem for the community—especially barn fires. This 1934 photograph shows a horse-drawn fire wagon, which was used to aid the bucket brigades. On January 11, 1954, the West Whiteland Fire Company was formed with a budget of $254.60. (Courtesy of Tom Jackson/ the Newlin family.)

This 1920s photograph shows members of the Newlin family sitting in a fire truck. This appears to be the first fire engine of the Lionville Fire Company, which was formed in 1911. Motorized fire trucks started to become more common in 1910, replacing older, steam-powered fire engines. (Courtesy of Tom Jackson/the Newlin family.)

This photograph was taken on Indian Run Farm in 1939. It is hard to imagine that this is where Main Street Exton stands today. It looks as though these boys are out for a joyride through the rolling valley. (Courtesy of Tom Jackson/the Newlin family.)

This photograph was taken in 1937. Richard M. Newlin saw to it that beautiful gardens were built on his estate, and this pond sat in front of the house. (Courtesy of Tom Jackson/the Newlin family.)

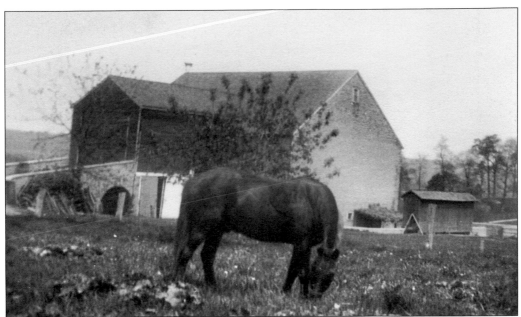

The above photograph shows the barn at Main Street Exton as it was when it was used on a functioning farm, while the below photograph shows the same structure in its current use as commercial space. In the 1960s, this barn was used to raise chickens. The long narrow building in front is a corncrib, which was preserved for its historic value. Native Americans were the first to use corncribs, and there are stories of struggling European settlers raiding these structures for food. Once the corn was harvested, it was placed in the corncrib to dry. Corncribs were usually elevated to keep out the rodents. Once the corn was dried, it could be ground into cornmeal or used to feed livestock. (Above, courtesy of Tom Jackson/the Newlin family.)

Pictured is the western view of the past and present barn. The Newlin children would collect apples from their orchard and take them to the Thomas Mill, where the fruit was ground into apple cider. The children would then operate a cider stand that sold the juice. The children would also ski down the barn's ramp during the winter months. In her article "Structures at Main Street Speak of the Property's Past" for the *Daily Local News*, Dorothy von Gerbig writes of the barn: "Because, whatever feelings any of us may have about 'development' we can't be sorry that this pocket of history will be preserved much as it was in the thick of the present, so that busy shoppers can pause and view it, walk within its whispered past, and perhaps grasp something of what it all means." (Above, courtesy of Tom Jackson/the Newlin family.)

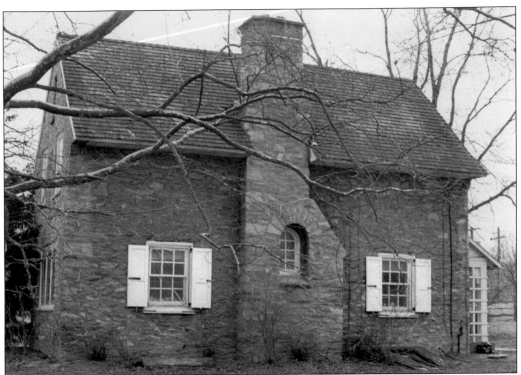

The Great Depression had no lasting effect on the Newlin family's wealth. These before (above) and after (below) pictures show a stone tenant house that was built during the Great Depression, using the best masons in the area. In a 1990s *Daily Local News* article, Dorothy von Gerbig observes, "The centerpiece of that time was this collection of stone buildings; that springhouse, the great barn, the animals that lived, were loved and died and were buried here; those special trees; all are almost holy to them, and all will continue speak to us of the way things were, once upon a time."

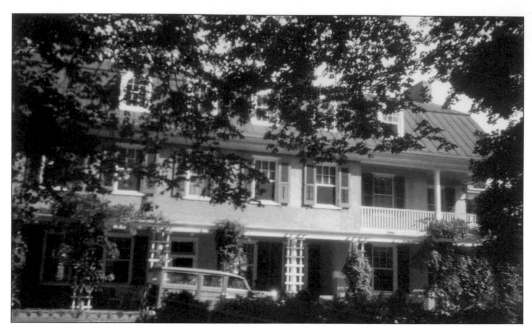

These photographs show the Ashbridge-Newlin manor house, covered in ivy, in 1938. This was the same year that Nazi troops invaded Austria and the US economy slipped into a recession, with unemployment at 19 percent. The average cost of a new house was $4,000.

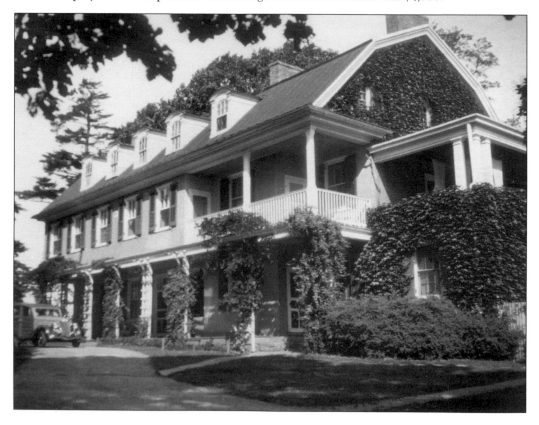

Five

WEST WHITELAND TOWNSHIP TREASURES

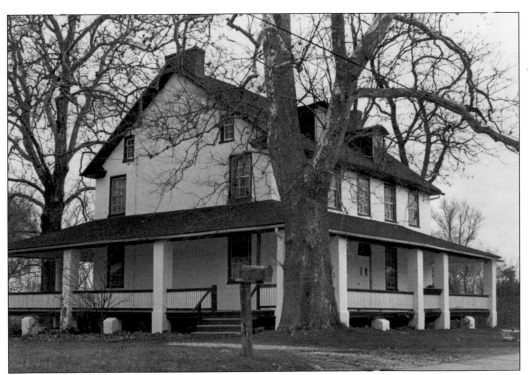

In the 1840s, Benjamin Pennypacker, a dairy farmer, built the Pennypacker House, located at 800 East Swedesford Road. The large wraparound porch was added after 1917. The house contains the only double beehive oven in Chester County, and it is listed in the National Register of Historic Places for its high level of architectural integrity. The style is symmetrical, with clean lines that show the value that the Quakers and Mennonites placed on simplicity and plain living.

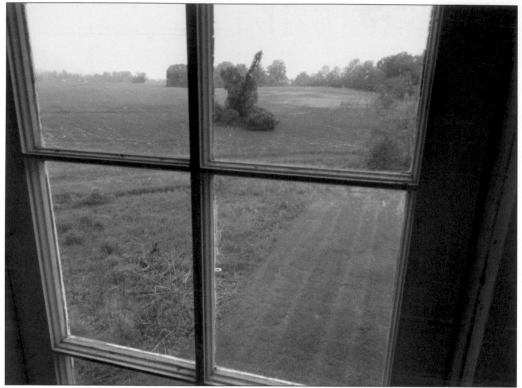

The views from the windows of the Pennypacker House are nearly the same as when the house was built. In 1918, this became one of the first properties acquired by the Church Farm School founder Dr. Charles Shreiner. Howard Avil, the farm manager, lived in the house before—and during—his employment at the school.

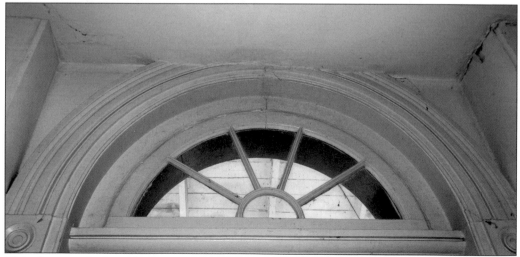

This photograph from the Pennypacker House shows a semicircular fanlight. The fanlight was installed for practical reasons rather than decorative ones, as—before electricity was available—it let natural light into the hallway. Benjamin Pennypacker was born in 1786 and died in 1851. The 1850 census lists his wife, Sarah Wertsner, and four children with last names other than Pennypacker. They were most likely "unofficially" adopted.

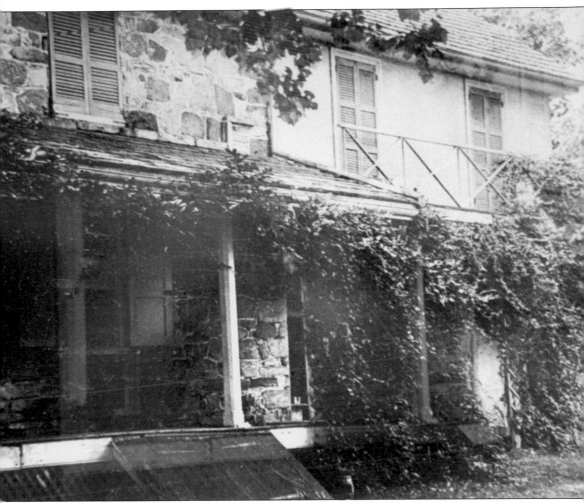

The Zook house, which is now located in the Exton Square Mall parking lot, was originally built by William and Elizabeth Owen in 1750. In 1760, a Quaker named James Brown purchased the house and land. In 1770, Moritz Zug purchased the house and its surrounding 150 acres, paving the way for the eight generations of Zooks who made this property their home. The sandstone walls are two feet thick, and at one time, the mansion was over 100 feet long—with gable walls covered in ivy and a hip roof. An article from 1918 describes it: "There are sixteen rooms, with a south porch looking over a beautiful stretch of valley, a fine stream in the foreground, and beyond these twenty acres of meadow the Lincoln Highway and the range of hills where deer have been foraging in recent seasons." Through the generations, this property has been used for farming, quarrying, and lime burning.

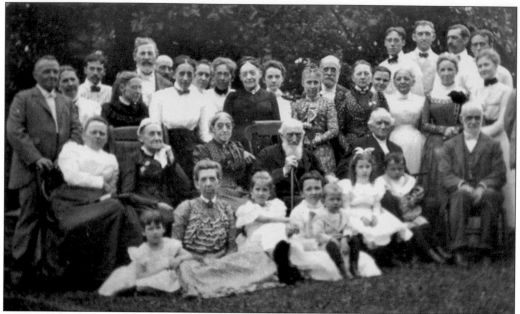

The Zook family members pictured here are descendants of Moritz Zug, the grandson of Hans Zug. Hans was imprisoned in Bern, Switzerland, for 13 years because, as an Anabaptist minister, he refused to baptize his children as Roman Catholics. Once he was released from prison, he was exiled from Switzerland and raised his 12 children in Germany. According to family history, Moritz—along with his two brothers—sailed to the American colonies aboard the *Francis & Elizabeth* in 1742, then was sold into servitude for two years to pay for his passage. Moritz died in West Whiteland Township at the age of 93. Once in America, the name Zug was anglicized as Zook, and through marriage, Zook blood was mingled with the prominent Ashbridge and Thomas lines.

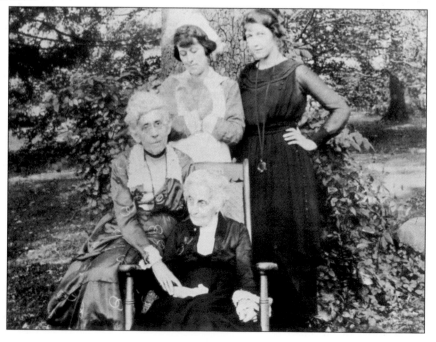

This picture is most likely from the early 1900s. In the late 1900s, an archaeological study was performed before the Zook house was moved to make room for Boscov's department store. Archeologists believed that, at onetime, the front yard was actually the backyard, where they uncovered broken pieces of imported English pottery dating from the 1770s to the 1800s. There were also glass beads, buckles, oyster shells, and food bones.

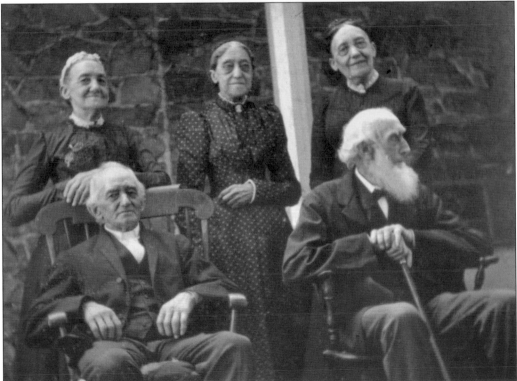

According to an article written in 1918, the Zook House was, in the late 1800s, "used as the headquarters of the West Whiteland Everhart Pioneer Corps, which met there to drill and to start for the rallies held in some of the most stirring campaigns the county of Chester ever saw. The six-mule team, decorated in gay style, would contain the band and be accompanied by a delegation of enthusiastic citizens."

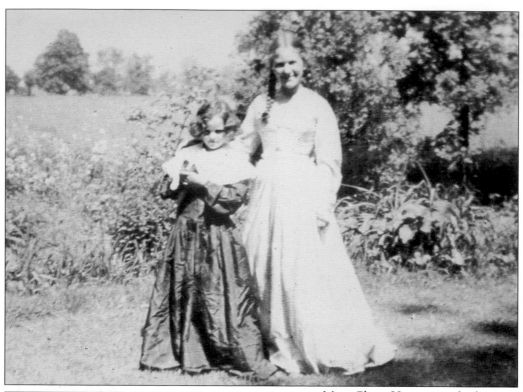

Mary Chase Howse was the last Zook descendant to live in the Zook house. The local elementary school, located on Boot Road, is named in her honor. The picture is associated with the Zook house, but there is no indication as to when it was taken or of the girls' identities.

This photograph was taken on the Zook property. The bell on the building may be that of a school, but it was most likely used to call cows or family members home, not students. The Zook property was often used as a stopping place for Mennonites and Quakers moving from Philadelphia to Lancaster.

The Exton Square Mall currently occupies the location of the field shown in this image. The girl pictured is unidentified, but her style of dress most likely dates to the late 1800s. Jacob M. Zook was county commissioner in 1878 and lived in the Zook house with his wife, Rebecca Ashbridge.

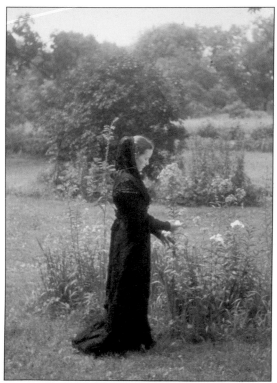

In 1998, the Zook house was moved to make room for Boscov's department store, which is part of the Exton Square Mall. The two-million-pound house was moved 200 feet to the southwest. Two 100-foot main beams were run through the house's basement, which were then lifted by 22 hydraulic ram dollies. About 25 steel beams measuring 28 feet in length were installed along the width of the house. During the move, the original 1750 basement was lost and a new concrete foundation was poured. Historic West Whiteland residences greatly benefit from the township's zoning ordinance, which protects historic structures.

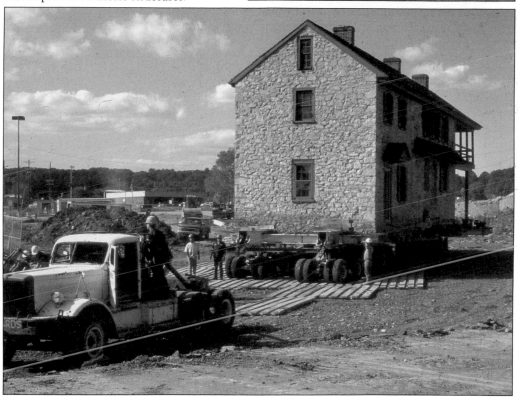

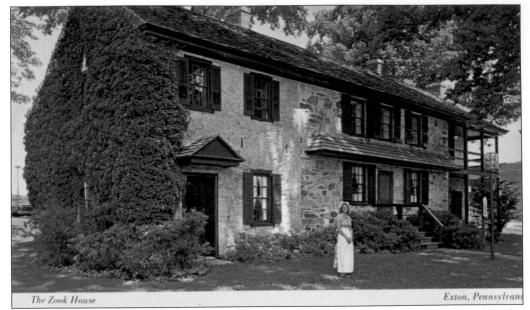

This c. 1976 postcard shows the Zook house before it was moved. The house was listed in the National Register of Historic Places on January 1, 1976. In July 2000, the house was relisted at its new location.

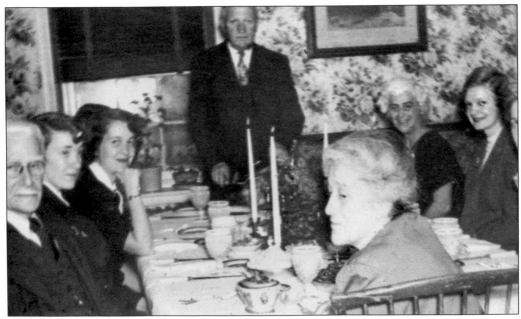

This picture shows the Zook family having a holiday dinner. It was probably taken in the 1940s. The head of the family is about to carve the turkey, the good china and silverware are on the table, and the candles have been lit.

Richard Thomas II built this unique wooden gristmill in 1744. The mill is located at 130 West Lincoln Highway, in the Nissan dealership parking lot. During the Revolutionary War, George Thomas managed the mill for his brother Col. Richard Thomas III. George, being a staunch Quaker, did not join in the fighting, but he did what he could to help end British rule at home. Family lore says that George had glass ground into the flour that was sold to, taken by, or given to the British army, and in 1787, George pioneered the process of putting lime in the soil as a form of fertilizer. Using water from a nearby pond to power the mill's huge waterwheel, the structure processed corn, wheat, oats, and plaster of paris and also served as a sawmill. The Thomas gristmill was owned and operated by the family from 1744 to 1935, and in the 1950s, it was used to press apples. The mill is the oldest extant mill in Chester County, and it was built using techniques that are rare in this part of Pennsylvania. In this c. 1941 photograph, John D. Thomas lifts flour bags into a wagon. (Courtesy of L.A. Sampson.)

In 2001, the Miller house was moved approximately 200 feet south of it original location, in order to make room for the Nissan dealership. As seen above, it was once fashionable to stucco a stone house, adding protection and insulation, but the stucco was eventually removed from the Miller house and, as seen below, it once again has a visible stone exterior. Throughout the 18th, 19th, and 20th centuries, the Thomas family owned and managed the property. The Hagee family—Thomas family descendants—owned the property until 1998, and some historians believe the gristmill beside the house to be one of the oldest timber-frame mills still standing in the United States. The mill first drew power from Valley Creek, but, as demand grew, a cast iron pipe was installed to carry water from a nearby pond.

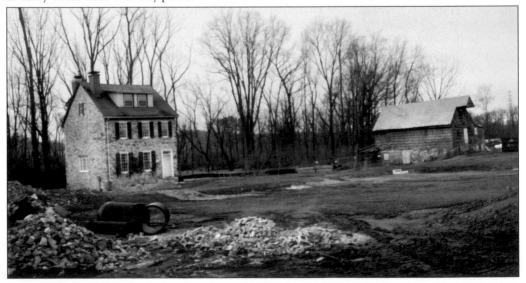

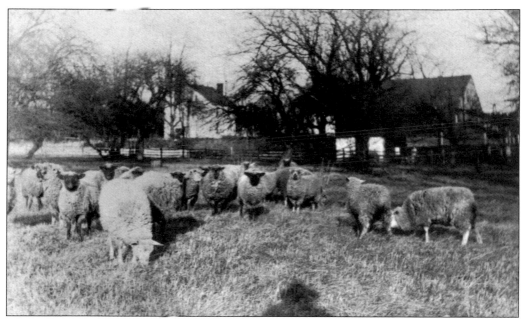

The miller's house, visible in the background of this photograph, is a stone structure, built in 1835 by Col. Richard Thomas. The home was located at 130 West Lincoln Highway. It was originally built as a tenant house for the miller who operated the Thomas Mill on the family's behalf.

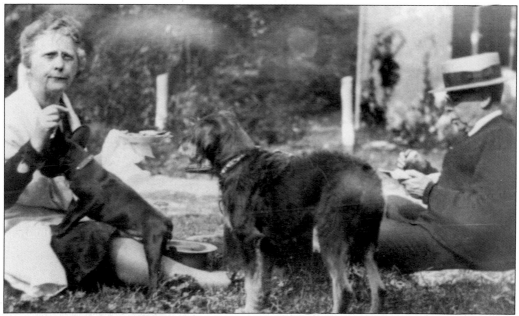

Here, Mr. and Mrs. John David Samuel enjoy a nice day by having a picnic with their dogs. When John died in 1954, the township named Samuel Road after him.

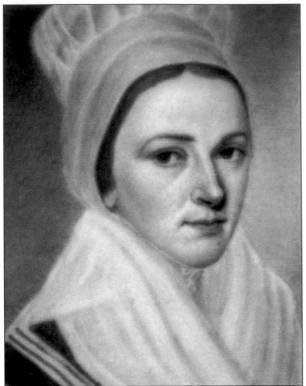

Phebe Ashbridge was born in 1717 and was married to Richard Thomas II, who is credited with the construction of the Thomas Mill. They had five children—one of whom was the extraordinary Richard Thomas III. Phebe was widowed in 1754 but later married William Trimble. Phebe's three daughters by Richard each married one of her new husband's sons. (Courtesy of Mrs. Henry Brown and Janet Ashbridge.)

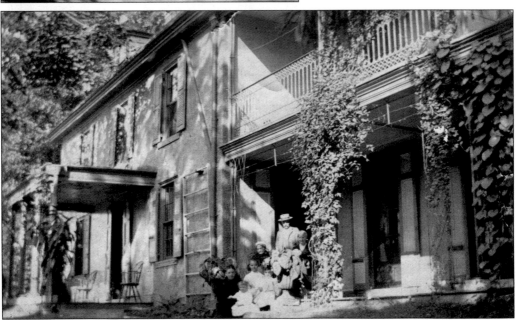

This c. 1900 photograph shows the Oakland Estate's south side. Located at 349 West Lincoln Highway, this Colonial stone house was built by George Thomas in 1772. George was the heir to 500 acres of land that belonged to his father, Richard Thomas II. When the Uwchlan Meeting House was being used as a hospital following the Brandywine Battle and several local skirmishes, this house served as a meeting place for local Quakers.

Six

THE HUNT

In 1913, a formal foxhunting group was organized in the area, called the Whitelands Hunt. In 1918, the Whitelands Hunt established its headquarters on Colebrook Farm, which was owned by Wikoff Smith. The farm encompassed 700 acres in three townships— West Whiteland, East Caln, and Uwchlan. (Photograph by Charles M. Clark, courtesy of Gail McCahon.)

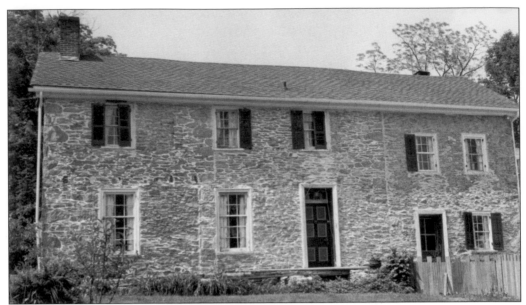

Before the Whitelands Hunt, another foxhunting group was formed in 1815. With members from East and West Whiteland, this group remained active until the 1850s. In February 1888, one of the largest hunts in the county began at Geroge Hoffman's Grove Farm (pictured). There were more than 70 horsemen and 75 hounds. This house is located at 1311 Grove Road.

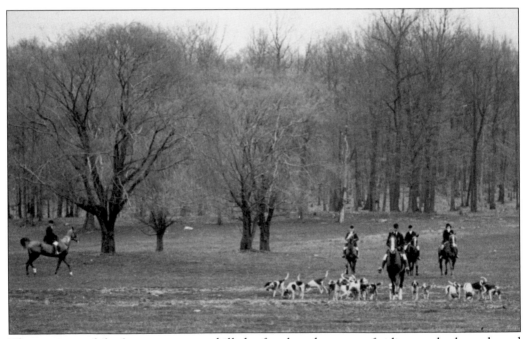

The purpose of the hunt was not to kill the fox, but the sport of riding to the hounds and observing their keen sense of smell as they followed the trail of the fox. The hunt would challenge the rider to jump fences and ride through streams, though it was very important for riders to respect the farmland and wishes of the landowners. (Photograph by Charles M. Clark, courtesy of Gail McCahon.)

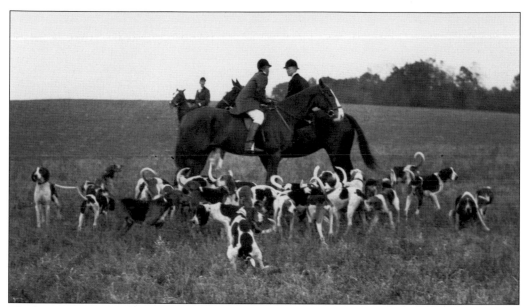

The huntsman and field master determined a person's position in the hunt field. The huntsman and whips—who kept the hounds together—were called first flight. Second flight consisted of the field master and the majority riders. The hilltoppers followed at a safe distance and often viewed the fox as it changed course. They would gleefully yell, "Tallyho," as a signal that the hounds were on course. (Photograph by Charles M. Clark, courtesy of Gail McCahon.)

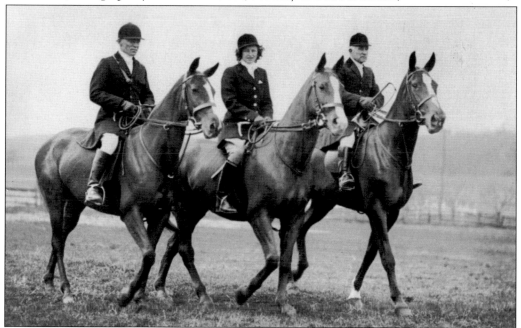

Seen here are, from left to right, Geo Hill, on his horse Fairy; Helen Huggler, on her horse Sandy Rock; and James Bray, on his horse Mistletoe. They are looking north from Colebrook Manor, which is located on Lincoln Highway—near the border of East Caln and West Whiteland Townships. There were staff positions associated with the hunt, and the riders that followed were referred to as the field. (Photograph by Charles M. Clark, courtesy of Gail McCahon.)

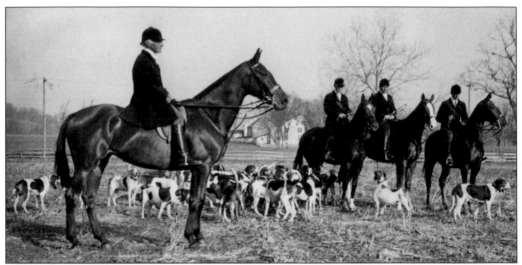

Shown here are, from left to right, master of the foxhounds Wikoff Smith; first whip Fred Hill; huntsman John Bray; and second whip Will Bray. The master of the foxhounds managed the breeding of the hounds and was responsible for appointing the hunt staff. The job of the whips was to assist the huntsman, and they were positioned on the flanks. The huntsman worked with the hounds. (Photograph by Charles M. Clark, courtesy of Gail McCahon.)

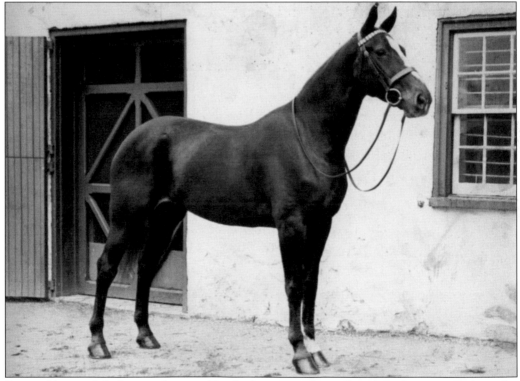

Pictured here is Mistletoe, a horse ridden by huntsman James Bray. The huntsman selects the hounds for the hunt and ensures they are collected at the end of the day. He uses a horn and voice commands to communicate with the hounds. If the huntsman views a fox during the hunt, he yells out, "Tallyho!" (Photograph by Charles M. Clark, courtesy of Gail McCahon.)

From 1914 to 1918, Richard M. Newlin served as master of hounds for the Whitelands Hunt. Newlin lived on the Indian Run Farm from 1914 until his death in 1950. He is pictured here around 1939. (Courtesy of Tom Jackson/the Newlin family.)

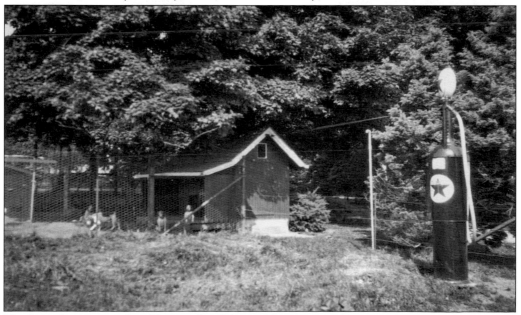

The hounds were raised and kept on local farms. Those pictured here are from Indian Run Farm, which was located at the current site of the Main Street Exton retail complex. These hounds were referred to as "trencher-fed," because they were kept with their owner and not in a kennel with the other hunt hounds. (Courtesy of Tom Jackson/the Newlin family.)

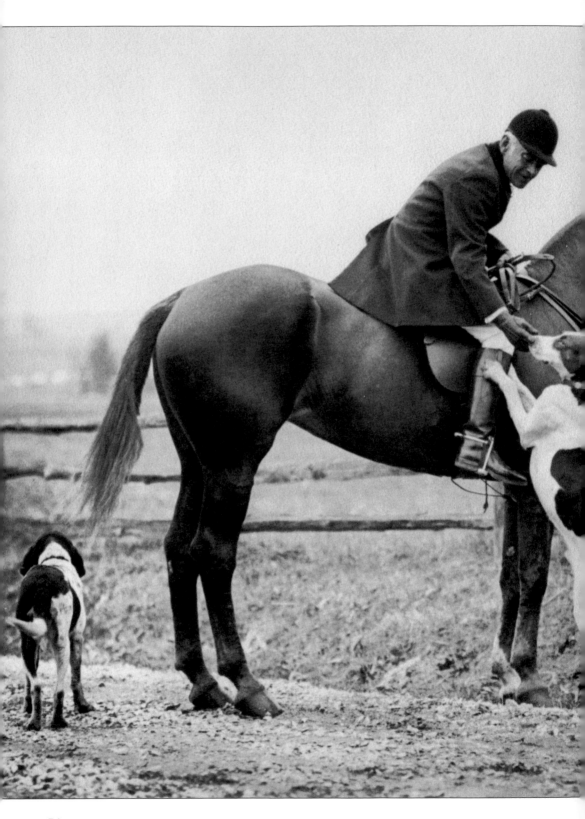

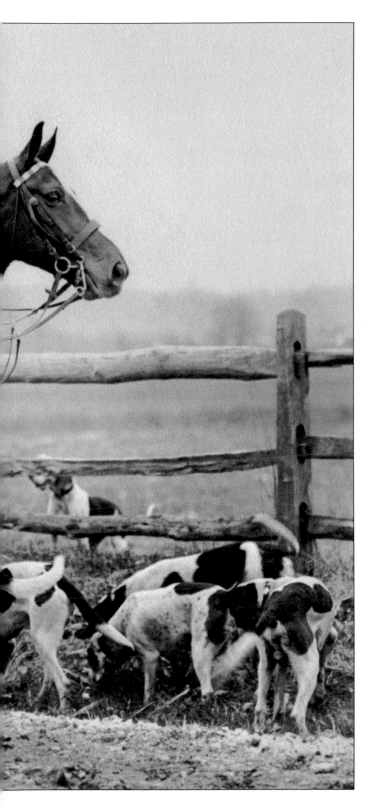

Pictured is the master of the foxhounds, Wikoff Smith (1876–1940). It is rumored that this was Smith's favorite picture. He purchased Colebrook Farm in 1914, housing the hounds in outbuildings and creating a headquarters for the Whitelands Hunt in the fieldstone manor house at 575 West Saxony Drive. The house now serves as the clubhouse for the Evian Homeowners Association. Smith was named for his great-grandfather Col. William Wikoff—who fought in the Revolutionary War and served as aide-de-camp to General Washington at the Battle of Monmouth. (Photograph by Charles M. Clark, courtesy of Gail McCahon.)

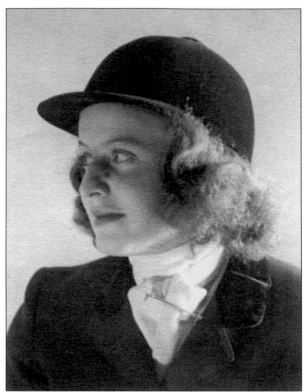

Helen Huggler Young, pictured here, rode with the Whitelands Hunt Club for many years. Wikoff Smith "unofficially" adopted Helen and her sister, Francis. Helen lived in the house across from Wikoff and his wife, Helen Potts, in Bryn Mawr. Wikoff named his new farm in West Whiteland Township Colebrook Farm, after his Colebrook Mansion in Bryn Mawr, Montgomery County. (Photograph by Charles M. Clark, courtesy of Gail McCahon.)

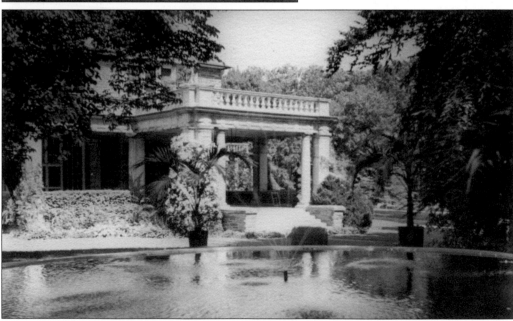

Pictured is Wikoff Smith's residence at 423 Colebrook Lane, Bryn Mawr. Helen Potts Smith's father built the mansion, though the true size of the building cannot be seen in this photograph. It was constructed of gray fieldstone and was similar to the style of Bryn Mawr College, which was less than a mile away. The house served the family for 40 years, but it became too costly to maintain and was demolished around 1950. (Courtesy of Gail McCahon.)

Seven

"Meet You at the Cow"

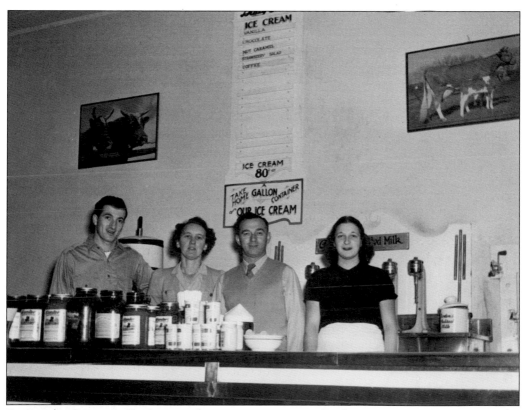

During the Guernsey Cow's years of operation, a common local statement was "Meet you at the Cow." In the early 1930s, the price for a quart of homemade ice cream was 80¢. As the business grew, so did the Guernsey Cow's list of interesting flavors. They eventually came to include the following: butter brickle, strawberry cheesecake, pinto pony, blue moon, Swiss chocolate mint, licorice, moon dust, and brandy peach. This photograph was taken in the early 1930s and features, from left to right, Elmer Polite (Ilario's brother), Gladys Polite, Ilario "Larry" Polite, and Millie "Dolly" Polite (Ilario's sister). (Courtesy of Sean McGlinchey.)

The Cow also sold farm-made cream caramels. According to Sean McGlinchey, "The caramels were sold in waxed cardboard tubs with a die-cut cow head in the top to give it a fun way to dispense the candies. The cow head was an easy reach for small hands but not too small for adult hands either." (Courtesy of Sean McGlinchey.)

This 1939 photograph of some of the Guernsey Cow's staff features, from left to right, Joe "Pep" Puliti (Polite), Elmer Polite (assistant food prep manager and scheduler), and Johnny Falini (ice cream dipper). Standing in front of them is Wanda Polite McGlinchey, the daughter of Larry and Gladys Polite. Although not pictured, employee Willie Minor was an icon at "the Cow." From the early 1940s to 1994, Willie lived and worked at the Guernsey Cow, where he helped make the ice cream, wash dishes, and mow the lawn. (Courtesy of Sean McGlinchey.)

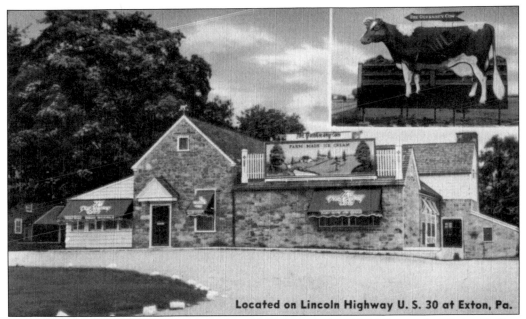

The text on the back of this postcard—postmarked September 10, 1941—reads, "Dairy Grill at Exton, Pa on Route 30. We welcome you to the Dairy Grill, – whether you be a neighbor or a guest from afar. We serve Guernsey milk, delicious ice cream and tempting sandwiches. Our caramels are famous. At the sign of the Guernsey Cow." (Courtesy of Sean McGlinchey.)

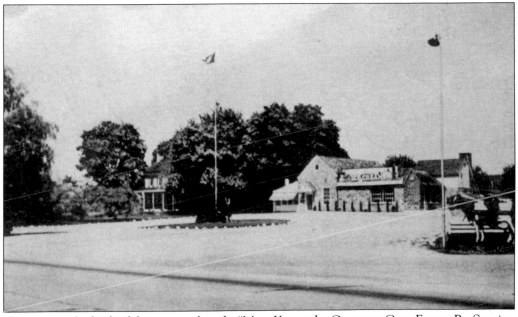

The text on the back of this postcard reads, "Meet You at the Guernsey Cow, Exton, Pa. Serving Tasty Luncheons – Internationally famous for our cream caramels, Ice Cream and Golden Guernsey milk. Landmarked by the World's Largest Cow." (Courtesy of Sean McGlinchey.)

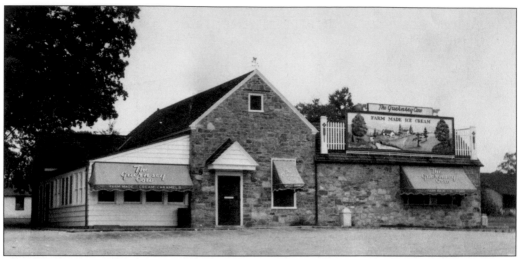

Sean McGlinchey, the grandson of Larry and Gladys Polite, once described the restaurant as "a major tourist destination in the half century before the population explosion of Exton, West Whiteland Township and surrounding Chester County, The Guernsey Cow was 'world famous' for its hand-crafted cream caramels and ice cream. It represented a pure slice of Americana and, in particular, the American Dream for our grandparents." (Courtesy of Sean McGlinchey.)

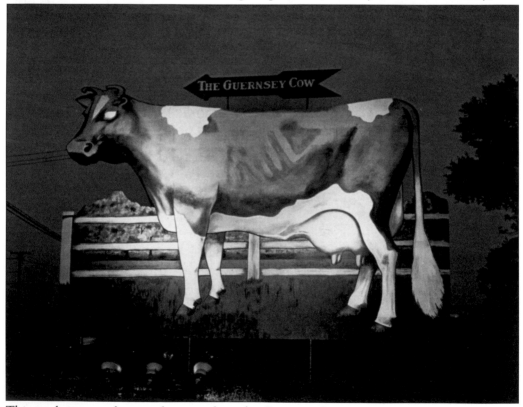

This steel sign stood across the street from the Guernsey Cow restaurant on Lincoln Highway. The eye would actually light up at night. An artist from Pottstown created the sign after World War II, and he also painted the signs on the building. (Courtesy of Sean McGlinchey.)

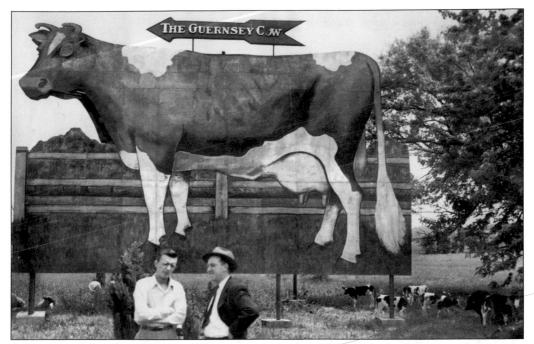

According to Sean McGlinchey, "Sometime in the late 1940s or early 1950s a truck carrying cows either overturned or broke down along the Lincoln Highway in Exton, PA in front of The Guernsey Cow. The cows, on the loose, were drawn to the giant Guernsey Cow billboard and milled around in its shade and that of the nearby trees. Meanwhile, serious men stood by pondering the best action to take." (Courtesy of Sean McGlinchey.)

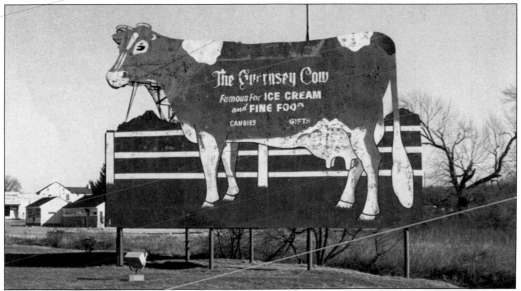

In July 1985, the head of the cow was stolen. In 2011, there was an attempt by the West Whiteland Historical Commission to find the head, and an article was even posted in the *Philadelphia Inquirer*—asking that if anyone knew where the head was located to please let the commission know and that there would not be any charges for the theft. West Whiteland Township currently has the sign, minus the head, stored in the township barn.

CARAMELS MADE FROM WHIPPING CREAM

SANDWICHES

No.			No.		
1	Ham _Baked_	20¢	12	Bacon and Egg	35¢
2	Cottage Cheese	15¢	13	Ham and Egg	35¢
3	American Cheese	20¢	14	Ham, Tomato and Lettuce	35¢
4	Liverwurst	20¢	15	Chicken Salad	40¢
5	Tomato and Lettuce	20¢	16	Sliced Chicken	45¢
6	Ham and Cheese	30¢	17	Club, Junior	50¢
7	Minced Ham	25¢	18	Club	65¢
8	Fried Egg	15¢	19	Cheese, Tomato and Lettuce	35¢
9	Bacon, Tomato and Lettuce	35¢	20	Sliced Turkey	50¢
10	Bacon	30¢			
11	Bacon and Cheese	35¢			

PLATTERS

31	Ham, Cheese, Tomato and Lettuce	50¢
32	Minced Ham, Tomato and Lettuce	55¢
33	Chicken Salad, Tomato and Lettuce	60¢
34	Sliced Chicken, Tomato and Lettuce	75¢

SHORT ORDER

Soups	15¢	Bacon and Eggs, Toast, Coffee	65¢	
Ham and Eggs, Toast, Coffee	65¢			

TRY OUR HOME-MADE ICE CREAM

BEVERAGES

Coffee	5¢	Hot Chocolate	15¢	
Tea	5¢	Buttermilk	10¢	

HOT CHOCOLATE MADE WITH MILK 15¢

MILK SHAKES

Chocolate - Vanilla - ~~Coffee~~ _Straw_

Plain	15¢	Float	20¢
With Ice Cream	20¢		
Malted	25¢		
Egg Malted	30¢		

SUNDAES
FRUITS IN SEASON

Maple Walnut	30¢	Chocolate	20¢
Chocolate Nut	30¢	Butter Scotch	25¢
Dusty	25¢	~~Fruit Salad~~	30¢
Pineapple	25¢	~~Cherry~~	25¢
~~Strawberry~~	25¢		

CHOCOLATE MALTED MILK - 25¢

At "the Cow," a person could pay 10¢ for a glass of Golden Guernsey Milk, so named for the golden color of the milk—derived from high beta-carotene levels. The Guernsey is a breed of cow from the island of Guernsey in the English Channel. With fewer than 2,500 Guernsey cattle registered in the United States, the breed is currently on the watch list maintained by the American Livestock Breeds Conservancy. (Courtesy of Sean McGlinchey.)

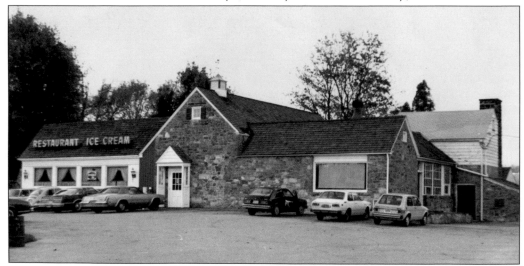

This photograph shows the Guernsey Cow restaurant as it appeared in its final years. The building, used as a restaurant for over six decades, now houses a bank. Memorials to the Guernsey Cow restaurant can be found on the Internet (Facebook page and website), and there is a permanent exhibit at the Chester County Library.

The team in this c. 1946 photograph is most likely from the West Chester Legion baseball league, sponsored by the Guernsey Cow restaurant. World War II ended the year before this photograph was taken, and it is likely that many of these young men served their country in the battles overseas. The members of the team pictured are, from left to right, (first row) Howard Durborow, William Fenstermacher, Joe Morton, Wallace Hunt, J. Finegan, Al Lawson, and Charles Clouser; (second row) "Scoop" Singleton, Larry Polite, Ira Oakes, John Pryor, Elmer Polite, William Young, Joe Reilly, Eddie Hayes, "Chick" Heald, Pete Himelright, and Horace Plunkett. (Courtesy of the Chester County Historical Society, West Chester, Pennsylvania.)

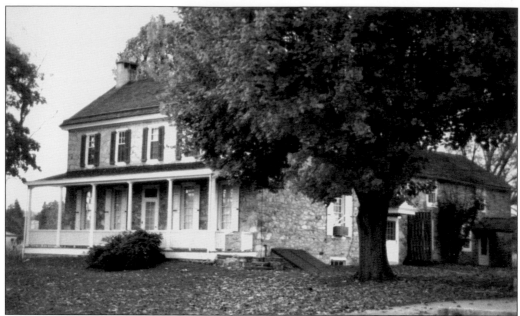

Sleepy Hollow Hall—also known as the Massey House—is located next door to the Guernsey Cow. The rear part of the house was built in 1685, but George Massey built an addition around 1740. Massey was a friend of George Washington, and because of this friendship, the owners can say that Washington slept in the house. The home was also an alleged stop on the Underground Railroad, with a hole in the second-floor ceiling serving as a hiding place. Additionally, Hugh Brannum—who played the part of Mr. Green Jeans on the children's television series *Captain Kangaroo* from 1955 to 1984—and his wife stayed at Sleepy Hollow Hall many times in the 1940s. At this time, the Polite family ran a bed-and-breakfast at Sleepy Hollow Hall and owned the Guernsey Cow restaurant. Pictured below in the 1950s are Wanda Polite McGlinchey (right) and an unidentified friend. (Both, courtesy of Sean McGlinchey.)

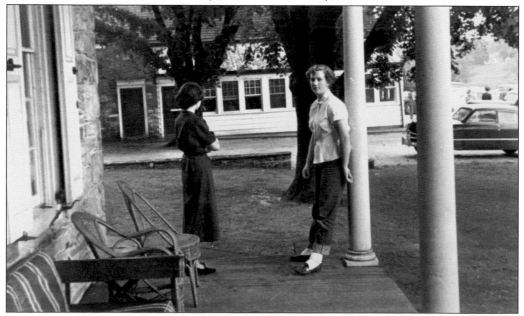

Eight

SPECIAL PLACES, SPECIAL TIMES

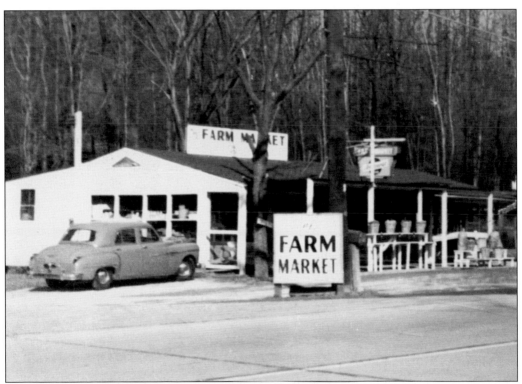

Pictured here in 1952, Felix Presto's Farm Market was located on Route 100, which was only a two-lane road at the time. According to a March 2, 1996, article in the *Daily Local News*, Felix started the part-time business with Francis and Max Morris in 1951. The only other businesses in Exton at that point were the Guernsey Cow restaurant and the Exton Diner.

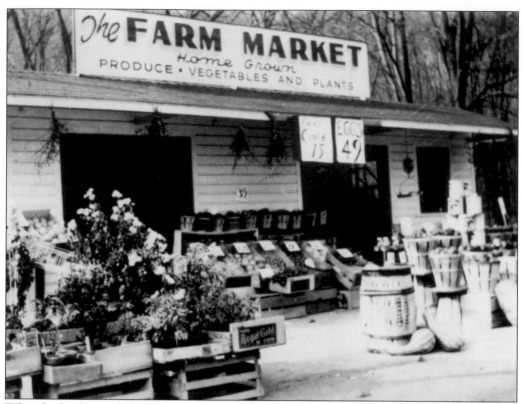

When he lived in Chester Springs in the 1960s, rock singer Jim Croce would stop by with his entourage for fresh produce. In an article by *Daily Local News* staff writer Gretchen Metz, Felix Preston states that the 1950s, 1960s, and 1970s were the business's lush years.

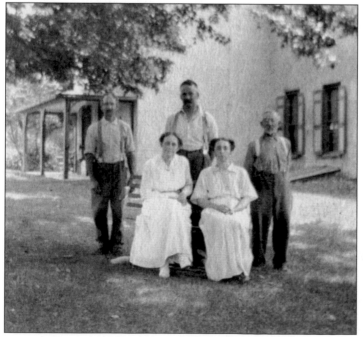

This photograph from the early 1900s features, from left to right, Charles T. Wells (born 1877), Anna Rhodes, unidentified, Lydia Rhodes Wells (born 1876), and Chas T. Rhodes. They were workers at the John Cuthbert House—also known as the Green Valley Farm—on North Ship Road. The house, visible in the background, was built in 1773 and continued expanding with additions until 1819.

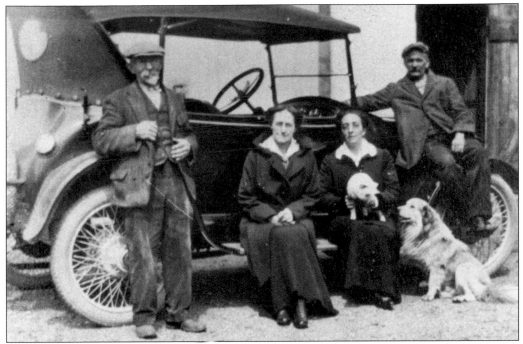

Seen in this photograph are, from left to right, Chas T. Rhodes, whose father ran the Whitford Store; his wife, Anna; their daughter, Lydia Rhodes Wells; and Lydia's husband, Charles T. Wells. Chas Rhodes and his daughter were killed on Lincoln Highway by an Entenmann's truck.

A note on the back of this photograph reads, "February 1941, Beatrice Shreiner (neice [sic] of Colonel Shreiner) and Knobby, who worked at Moses Mill." Colonel Shreiner, founder of the Church Farm School, was known as "the Colonel" because of his strict standards for the boys attending the school. The picture appears to have been taken along Lincoln Highway, with the Trimble Tenant House visible in the background.

The structure at 407–408 East Lincoln Highway was known as the blacksmith shop, which was converted into a wheelwright shop, then into a garage that served the village of Exton. Blacksmiths and wheelwrights were modest trades that usually hired, at the most, only two employees. When this picture was taken, the house in the distance was known as the Trego House.

This photograph of a house at Turnpike Station (411 East Lincoln Highway) shows where the Chester Valley Railroad had a crossing signal. The crossing signal no longer exists, but walkers and cyclists enjoy the Chester Valley Trail daily. The house was constructed by John Bowen—builder of the Ship Inn—around 1800 as a tenant house for blacksmiths and wheelwrights who had shops on the Lancaster Turnpike.

This photograph from the early 1900s shows one of the Thomas farms, which included Whitford, Oaklands, Fairview, and South Hills. The Thomas family owned more than 1,000 acres. Pictured are two dairy farmworkers and one of the Thomas children. Note the metal milk container carried by the man at right. Today, reproductions of these containers are located around the Exton Square Mall. West Whiteland Township was known for its fine herd of Guernsey cows.

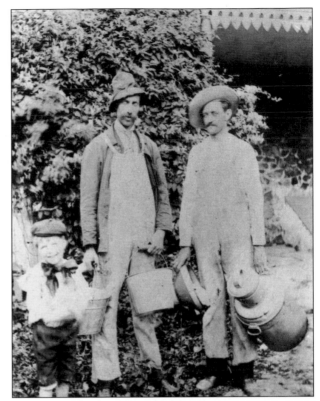

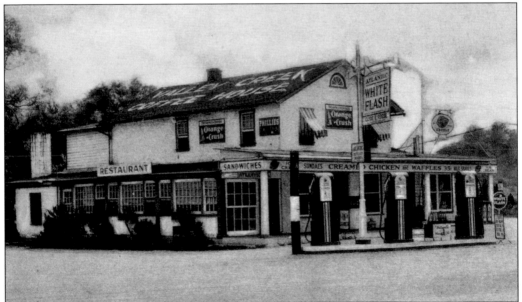

The Valley Creek Coffee House did not just serve coffee; it was also the home of the Exton Post Office from 1935 to 1960. In a July 28, 1994, *Philadelphia Inquirer* article, Catherine Quillman writes, "'Business was a lot different back then. For one thing, my mother did all the cooking,' recalled Reese, who worked with his parents and three brothers. 'My mother was also the postmistress in Exton for 28 years. The post office was right there in the restaurant.'"

ROUTE—147—AND LINCOLN
WHITELAND PA.,,

In the same *Philadelphia Inquirer* article, Earl Reese reminisces, "In the late 1930s to early 40s, when I was a kid, there used to be a man from the Keystone Corporation who stood out in the center of Route 30 and directed traffic. This was long before the first [traffic] lights were put in. He would hold up a sign that said Stop on one side and Go on the other." Pottstown Pike

(Route 100) was known as Route 147 in the 1930s. In the 1950s, Pottstown Pike (Route 100) was widened, and the coffee house had to be moved. Signs shown in this picture advertise Clyde Reese Atlantic Gasoline, Orange Crush, Coca-Cola, Eisenlohr's Cinco Cigars, hot dogs, and Whistle soda. (Courtesy Ella Rodney.)

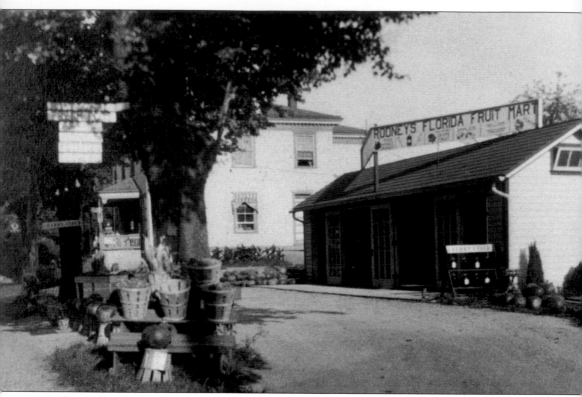

Rodney's Florida Fruit Mart was located at 290 East Lincoln Highway. The fruit stand pictured here is located just west of the house, but it was later moved to the front of the house—while the Rodney family lived in the rear. The Zook family originally built the house in 1820, and it is known as the Jacob Zook house because Zook built the stone structure after receiving the property from his father, Moritz Zook, who was among the first Swiss German immigrants to reside in West Whiteland Township. The property remained in the Zook family for 149 years, until the large number of automobiles on Lincoln Highway led to the property being sold to Warren Moses in 1919.

The Jacob Zook house is visible here, though it has since been integrated into a shopping strip. Some of the businesses that have occupied the first floor include Fante's Kitchen Shop, Green Papaya, and Biryani King. The Baldgaet sisters are pictured here in 1918.

Pictured in 1930, this Ford was used to deliver plants, fertilizer, and general merchandise from Rodney's Country Store. The average person did not own a car in the 1930s, which made delivery service a necessity rather than the luxury that it is today.

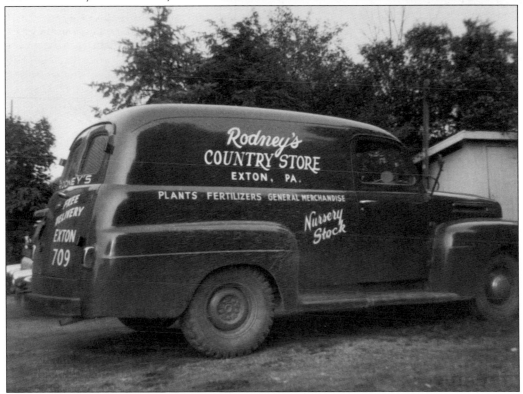

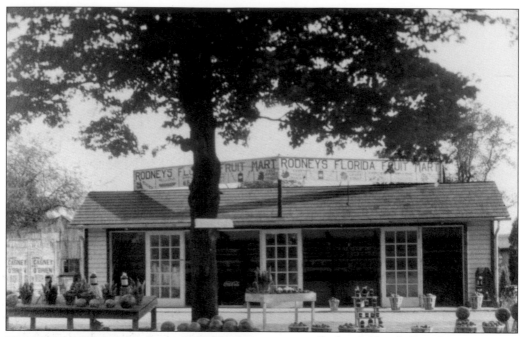

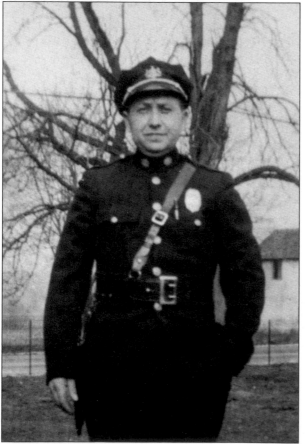

Rodney's Florida Fruit Mart is pictured above, while its owner, Ernest Rodney, can be seen at left in the uniform of his other job— serving as the township's constable. The Rodneys purchased the property in 1911, and in *A History of West Whiteland*, Rodney recalls, "Prior to 1920, turkeys were driven along Route 30 from Lancaster County to Philadelphia. At night they roosted in the trees, but at crack of dawn the turkeys was off the roost and was ready to go." Much later, developer Jack Loew planned to acquire and demolish the house. In a May 25, 1997, *Philadelphia Inquirer* article about the issue, Susan Weidener quotes Cindy Drager: "He [Giunta] wasn't aware there was any historic significance at all to the building, but once he found out, it caused him to change his thinking and not sell it to Loew."

Seen in this photograph are, from left to right, a young Ernest Rodney, a Mr. Sturges, and Moses Coal. This c. 1910 automobile features a horn that was possibly known as the Gabriel. The Gabriel, named for the angel, was popular in the early 1900s. It made a powerful sound, but was not as piercing as earlier horns.

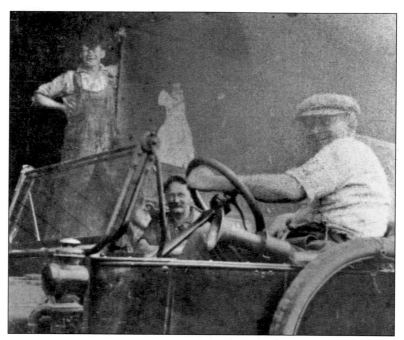

This picture was taken in 1979—during the second oil crisis—at the intersection of Pottstown Pike and Lincoln Highway. The fear of a war between Iran and Iraq caused a decrease in oil output; thus, the population panicked and long lines at the pumps were a common sight.

The Williams Deluxe Cabins (511 East Lincoln Highway) were located on Lincoln Highway, which was the United States' first coast-to-coast highway. It was initially regarded as a "worn out turnpike toll road for horse and buggies," but as more Americans began to acquire automobiles, there was a need for economical, convenient overnight lodging. In the 1920s, tourist camps began to spring up along America's highways. At first, these camps just provided tents, tables, and chairs, but they eventually provided cabins. In 1937, Leon H. Williams constructed a motor court, featuring cabins, a service station, an office, and a house. Williams operated the motor court until 1964, when he sold the property to the Dyffrin Construction Company. The name was changed to the Tudor Motor Inn, as the cabins were built in the Tudor Revival style. Some may remember the office as Ichabod's Used Paperback Book Nook.

Chester WILLIAM'S DELUXE CABINS
On Route 30 Exton, Penna.
Modern in every respect.
Phone: Exton 759

UBLISHED FOR HAYDON ORD MERRILL, BYWOOD, UPPER DARBY, P.

THE FINEST AMERICAN MADE VIEW POST CARDS—THE ALBERTYPE CO., BROOKLYN, N. Y.

HANDCOLORED
POST CARD

2.00

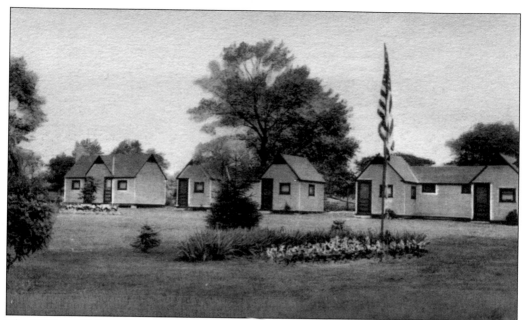

The Williams Deluxe Cabins are listed in the National Register of Historic Places. The register identifies properties that are worthy of preservation. It is a list, organized by the National Park Service, that was authorized by the National Historic Preservation Act of 1966. This property is considered significant for its ties to the development of national transportation.

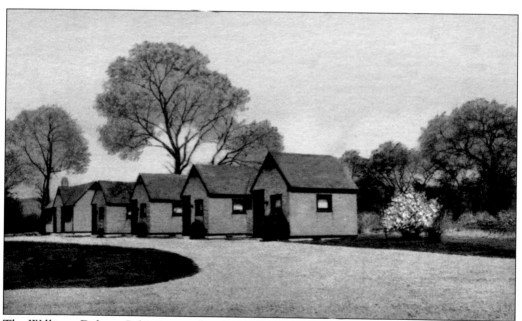

The Williams Deluxe Cabins started with just four units, and then two more were built. In the mid-20th century, the last three cabins were constructed. The following quote from a February 10, 1993, *Daily Local News* article written by David Slade refers to the cabins: "'It's a living history,' Butko said. 'So often, the businesses along old roads are left to rot.'"

Famous architect Frank Lloyd Wright originally designed Folly Cottage for his adopted daughter, Svetlana (Hinzenberg) Peters, but she died in a car accident in 1946, prior to the plans being implemented. Built into a steep hill, the cottage uses wood and stone materials to blend into the landscape. The design is based on triangles, and as such, has only one right angle. Folly Cottage was built as a weekend retreat and features only three rooms, with an added one-room guesthouse.

This fireplace in Folly Cottage was made from hand-cut Tennessee fieldstone. A typical material found in Frank Lloyd Wright designs, Tennessee fieldstone has been used for construction of chimneys and grave markers for hundreds of years. Other materials used were cypress for the exterior and Honduras mahogany for the interior.

Mr. and Mrs. Fredrick Royston purchased the plans for Folly Cottage from Frank Lloyd Wright's protégé, John H. Howe. The Roystons had purchased seven acres of a wooded track in West Whiteland Township on which to build their weekend retreat. In 1960, construction began on Folly Cottage, though it took three years to complete and came in well over budget.

Frank Lloyd Wright believed in organic architecture—a design in which all elements are related to one another, as reflected in nature. It is a style that promotes harmony between nature and humanity. One of his most well-known designs, Fallingwater, is located in Fayette County, Pennsylvania, southeast of Pittsburgh. Wright died in 1959.

This photograph shows the inside of the guesthouse, which was designed as only one room. Frank Lloyd Wright did not just design buildings; he also designed objects like light fixtures, decorative accessories, furniture, and art-glass windows.

In 1974, an art gallery was founded on the property of Folly Cottage, known as the Nelson Rockefeller Collection Folly Gallery. The gallery acquired the Rosenthal studio's Linie Collection. Available for purchase were porcelain, crystal, and coordinated flatware, all of which had been designed by Henry Moore, Salvador Dali, and Victor Vasarely.

Nine

TREASURES LOST

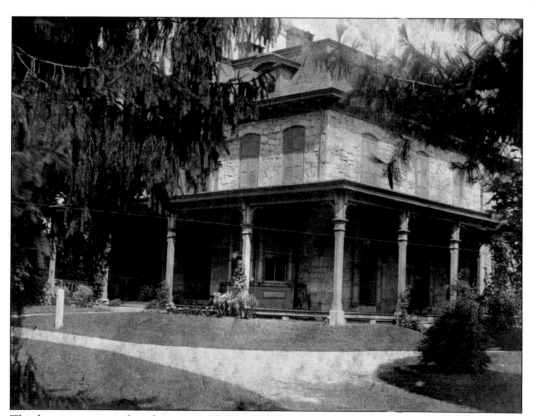

This house once stood at the corner of Whitford Road and Route 30. Known as Lindenwood, it was the home of J. Preston Thomas—a farmer and civic leader. Thomas was one of the founders of the Chester County Hospital, but he served the community in many capacities, including director of the Poor of Chester County and president of the National Bank of Chester County.

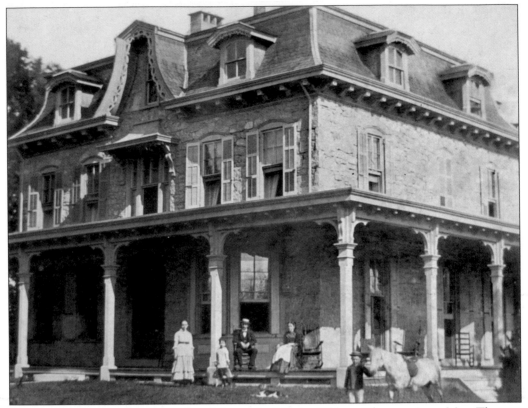

This c. 1885 photograph features, from left to right, Martha Gibbons Thomas, Anna Mary Thomas, J. Preston Thomas, Hannah Thomas, and George Thomas III. Martha Gibbons grew up to be a woman of firsts: She was a member of the first graduating class of Bryn Mawr College, the first woman from Chester County to be elected to the Pennsylvania House of Representatives, and an active member in the women's suffrage movement.

This magnified view provides a closer look at George Thomas III. In 1905, he built Whitford Garne, which is in the area of the Indian King housing development. George did not follow in the family tradition of farming but became an employee of Lukens Steel.

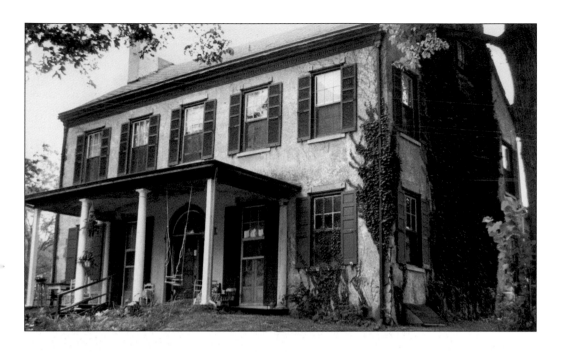

Summit Hall was located at 640 East Lincoln Highway, on the Springdale Farm. Oliver Bowen, whose father built the Ship Inn in 1796, began construction of this elegant Federal-style home in 1822. In 1826, Thomas H.B. Jacobs, Oliver's brother-in-law, completed the house after Oliver's premature death. The Jacobs family owned the property for 113 years, enjoying the home's 12-foot ceilings, black marble fireplaces, and marble windowsills. The West Whiteland Historical Commission fought hard to save the house, but in 1982, Hough-Loew Associates tore down Summit Hall to make room for the Whiteland Business Park.

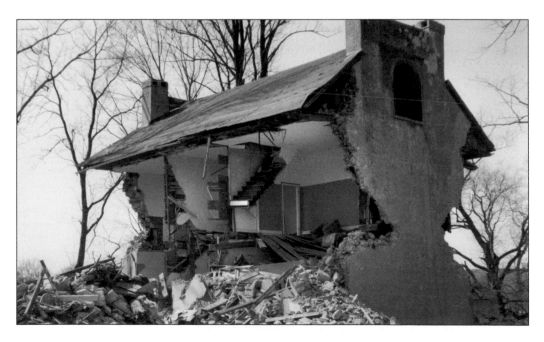

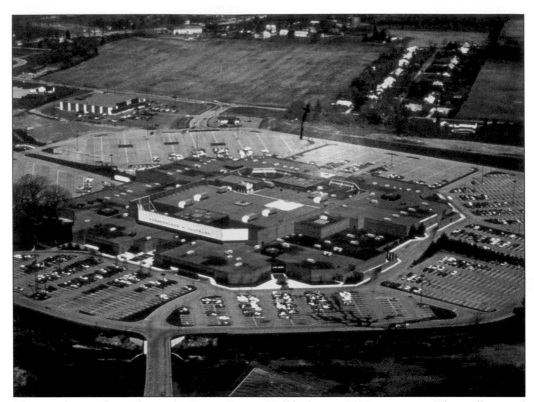

The aerial view above shows the Exton Square Mall before its 1997 expansion. The mall opened its doors in August 1973, with Strawbridge & Clothier (below) as its anchor store. In 2006, Strawbridge & Clothier closed its doors, and Macy's occupied the space. The Exton Square Mall helped to grow businesses and the population, boosting it from about 7,000 in 1970 to 12,400 in 1990. The area's current population is over 18,000. According to a July 29, 2005, article posted by *Philadelphia Inquirer* staff writer Wendy Tanaka, "Brian Ford, a partner in the Philadelphia office of Ernst & Young L.L.P., was both wistful and pragmatic about the demise of Strawbridge's, founded as a dry-goods store by Justus Clayton Strawbridge and Isaac Hallowell Clothier in the 1860s. 'Strawbridge's is the last regional department store chain in the area,' said Ford, who specializes in retailing."

Pictured is the old West Whiteland Township municipal building, which was razed in 2013. According to the township website, "Together, the Board, staff, and volunteers forge an organization that provides excellent public safety, public works, planning, historic preservation, parks, wastewater, solid waste and recycling services for residents, visitors, businesses, and organizations within West Whiteland Township."

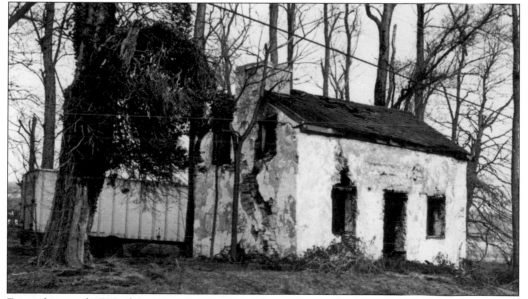

Erected around 1798, this weaver's cottage was located near the intersection of Swedesford and North Ship Roads. The stone remains can be seen near the Swedesford Chase Development. The weaver who lived in this house was John Quinn, the owner of the first tavern in the township, the Fox Chase Inn. Before the building burned in 1976, it was used as a Boy Scout cabin.

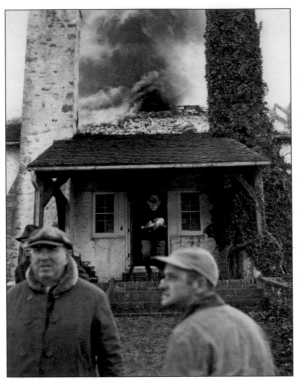

On December 28, 1952, at Whitford Road and Lincoln Highway, 100 firefighters from the Lionville, Downingtown, and West Chester fire companies fought a blaze that broke out when Bill Balderston tried to thaw a frozen pipe in William McIlvaine's barn. Balderston rented out a portion of the barn from owners William, Donald, and Thomas McIlvaine and their aunt, Annie Thomas. A herd of 50 dairy cows was led out of the barn to safety, but a strong north wind caused the flames to spread to Mrs. Lardner Howell's home. The two fires caused $52,500 worth of damage. Harold Martin, owner of the Exton Lodge; Dick Thomas, owner of the Brick Oven; and two ladies' auxiliary groups served coffee to the firefighters who fought the flames for nearly six hours. (Both, photograph by Ned Goode, courtesy of the Chester County Historical Commission, West Chester, Pennsylvania.)

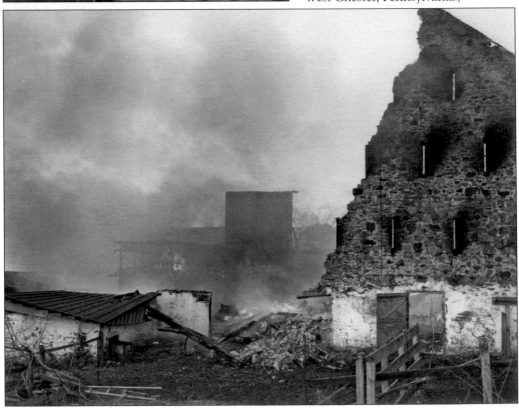

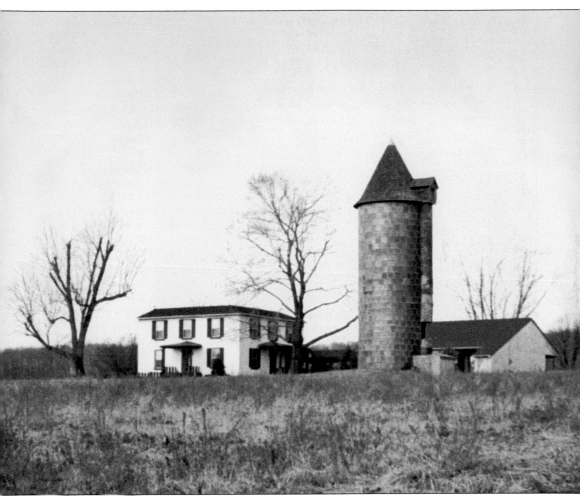

This tenant house on the Ship Farm land no longer exists. It was located at 328 North Ship Road. The house was built in the 1880s, but in the 1970s, the roof was damaged after a storm. The witch's cap from the silo is now owned by West Whiteland Township. In a March 19, 2001, article for the *Daily Local News*, Pateen Corcoran describes it as "a 19th-century, 15-foot cap made of cedar shake material that had been used to top a farming silo [and] will be stored by the township until its future use is decided . . . 'It was saved at the request of the township, and since then we've been trying to figure out what to do with it,' said Assistant Township Manager Steve Brown . . . The board of supervisors has chosen to take ownership of the silo cap and move it to a temporary home at a township site. It could eventually be placed in the planned Exton Park . . . 'It's highly unusual,' said Historical Commission Chairman Bruce Flannery. 'It's a highly decorative cap for a silo. It's a throwback to an earlier time.' "

112 North Whitford Road was a tenant house that was used on J. Preston Thomas's farm, known as Lindenwood. Samuel Fisher Jr., who was born in the tenant house, stated that Mrs. Chandler built the house for his father, who was Mrs. Chandler's chauffeur. Fisher remembered a potbelly stove in the living room, which was used to heat the entire house.

This home, which at onetime stood at 225 Shoen Road, was demolished in 1987. It once belonged to James D. Peck and was part of a 119-acre farm. Some of the land was eventually used for mining, first by Peck's sand mining company, then by the West Whiteland Silica Company. The Chester Valley Railroad had a branch that served the mine.

The Exton Drive-In first opened in 1956. It was located down a long driveway, with an entrance on the northwest corner—near the intersection on Pottstown Pike and Lincoln Highway. The theater fit a total of 800 cars. In 1985, the popular band the Hooters filmed the video for its song "And We Danced" at the Exton Drive-In, using many local residents (pictured). The theater closed in 1990. (Photograph by and courtesy of William Kates.)

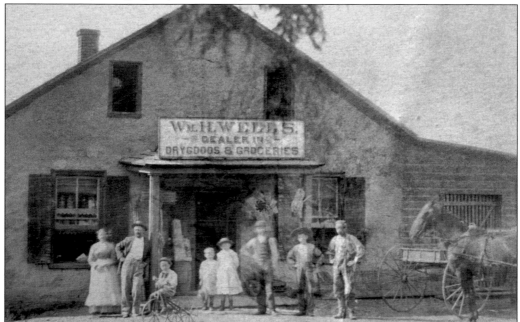

The sign in this turn-of-the-century photograph reads, "Wm. H. Wells, Dealer in Drygoods & Groceries." At one point in its history, this building was also home to LeRoy Campbell, General Merchandise. In 1826, the structure also served as the area's first post office, named West Whiteland. In 1843, the name was changed to the Belvidere. Levi Evans was the township's first postmaster.

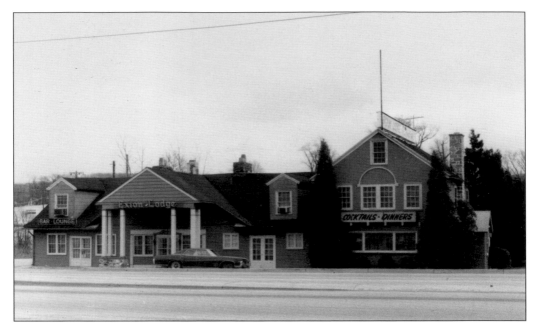

The Exton Lodge was a motel used by travelers throughout the 20th century. It was home to Marty's Bar, which was frequented by locals and travelers alike. In 1952, Henry T. MacNeill created the pen-and-ink drawing shown on the postcard below. The text on the back of the postcard reads, "Exton Lodge is a popular Inn, serving the finest food. It is in the heart of Chester County, surrounded by historic landmarks of national interest. Rooms for tourists. Modern Motel. Cocktail Lounge. Banquets, Weddings and special parties arranged for. Call Exton 711 for reservations. Exton Lodge is open daily and Sunday from 10 A.M. to 3 A.M. Harold E. Martin, Owner and Manager. Printed by the Stephen Moylan Press, Whitford, PA."

Exton Lodge, on Lincoln Highway at Exton, Pa.

Ten

WORSHIPPERS, STUDENTS, AND TRAVELERS

St. Paul's Episcopal Church (910 East Lincoln Highway) is the oldest church building in West Whiteland Township. During the Civil War, the church was used as a hospital after the Battle of Gettysburg. Dr. Charles "Colonel" Shreiner, who founded the Church Farm School, was the rector for 27 years.

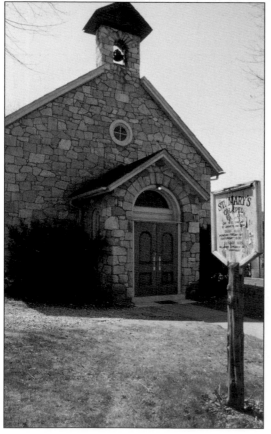

St. Mary's Chapel of the Immaculate Conception is located at the south intersection of Ship Road and Lincoln Highway. The ceiling was originally painted to depict the heavens, with stars and the moon. This chapel served as a mission church from 1873 to 1959. Mission chapels were established in the hopes that they would eventually form their own parishes, then send out missions of their own.

St. Mary's Chapel of the Immaculate Conception was built to serve the Irish Catholic immigrants who had left Ireland during the devastating agricultural depression of 1871–1872. The baptismal records show that 90 percent of the baptisms were performed on first-generation Irish immigrants. Many of them worked for the Pennsylvania Railroad, marble quarries, or the iron ore and silica mines.

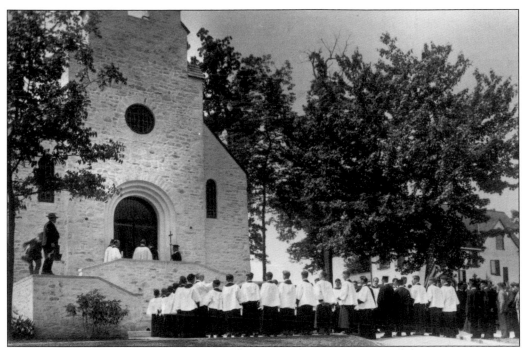

Architect Milton Medary, often used by Clarence Sears Kates, designed the Church of the Atonement (Church Farm School chapel), built in 1927–1928 on East Lincoln Highway, in a Spanish Colonial style. In 1963, architect Arthur Smith enlarged the church.

The Church Farm School choir poses on the stairs of the Chapel of the Atonement in this c. 1929 photograph. Over the years, the boys' choir has earned both regional and national recognition. In 1927, Roland L. Taylor donated $35,000 to purchase a pipe organ for the choir after he heard the boys sing with the accompaniment of a worn-out organ. (Courtesy of Jim Tate and the Church Farm School.)

This photograph of Grove Church, at 490 West Boot Road, may be unfamiliar, but this is the church in March 1887, just before it was demolished. The Grove Methodist congregation was first formed in 1773, making it the oldest Methodist congregation in Chester County. In 1783, George Hoffman, a German immigrant, provided property for a chapel to be built. By 1844, a new church was needed, resulting in the church shown in this photograph. This church had its main entrance on the opposite side of Boot Road, facing south toward the cemetery. The present-day Gothic Revival church was built in 1888, using green serpentine stone from the Brinton Quarry in Westtown. In the Grove Cemetery, there is a tombstone marked "1776." The Grove Historic District is listed in the National Register of Historic Places. (Photograph by W.F. Grubb, courtesy of the Chester County Historical Commission, West Chester, Pennsylvania.)

In this c. 1924 photograph, two adorable Newlin children sit on the front steps, proudly holding their buckets. This may be a picture from the first day of school, with the children displaying their lunch pails. (Courtesy of Tom Jackson/the Newlin family.)

These are eighth-grade students from the Ship Road School (101 North Ship Road) in 1926, standing with their teacher, Tack Embree. In 1863, the Jacobs family provided the land for the school. A one-room schoolhouse was built around 1865. In 1906, Frank F. Brown added a second floor. This was the largest school in the township for many years. SS. Philip and James Parish currently uses this building. (Courtesy of Mrs. John Young.)

Pictured is Miss Paschall, a teacher at the Ship Road School in the 1920s. Students who performed well on standardized tests were asked to attend a local teacher's college, sometimes at an age as young as 16. The student would attend a teacher's college, like West Chester State Normal School, for two years. Once they obtained their teacher's certificates, students only had to be 18 to teach 30–45 students, aged 5–18, in a one-room schoolhouse. (Courtesy of Ella Rodney.)

The 1938 photograph below shows Field Day at the Ship Road School. This was the same year that Jewish children were banned from attending school in Germany and that Pennsylvania children were required by law to attend school until the age of 17. Further, the federal Fair Labor Standards Act of 1938 banned children under the age of 14 from holding paid employment.

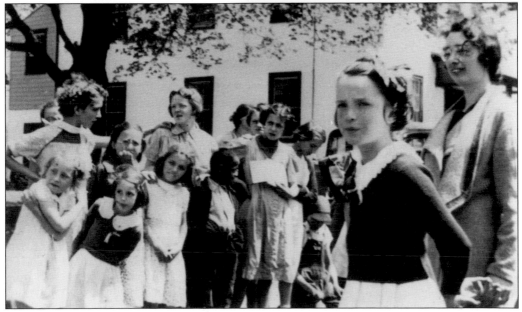

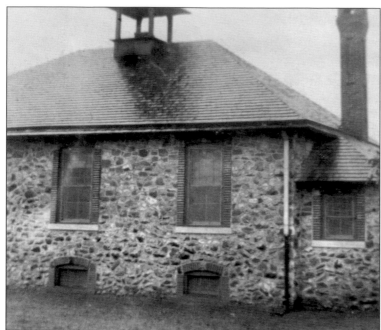

Charles Townsend Thomas donated an acre of land, plus the building stone, to erect the Whitford schoolhouse for children in the northwest quadrant of West Whiteland Township. The schoolhouse was built in 1895 at the cost of $2,225. It was the first school in the area to have central heat—no more loading the Franklin stove with wood in the mornings.

All children attending local schools had instruction in sewing. The Whitford schoolhouse was unique, as it had a special room called the "manual training room" where the children learned domestic skills.

This c. 1922 photograph of the Church Farm School baseball team features Coach Bashore at far left. The Church Farm School is located along East Lincoln Highway. The Reverend Charles Wesley Shreiner founded the school in 1918. As a successful baseball pitcher and dropkicker, Reverend Shreiner had the opportunity to attend the US Naval Academy. Reverend Shreiner credited this experience with giving him the ability to devise regimens that were successful at the school. (Courtesy of Jim Tate and the Church Farm School.)

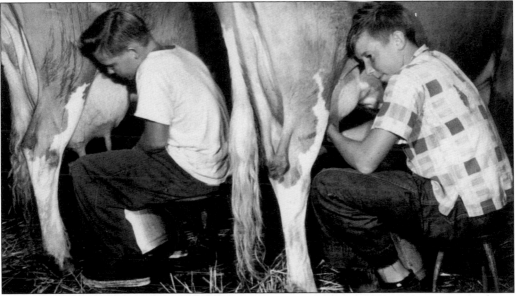

Pictured milking the cows are milk squad captains Jim Tate (left) and George Rambo. Ninth graders were eligible to be milkers and were paid $1 each week, with squad captains receiving $2. Tate was instrumental in creating the book *Vision and Ability, A History of CFS*. He also served on the Church Farm School's board for 46 years. (Courtesy of Jim Tate and the Church Farm School.)

On September 21, 1940, Donald McIlvaine, president of the West Whiteland School Board, placed a copy of the *Daily Local News* inside the cornerstone of the West Whiteland High School. McIlvaine lived on his family farm, Oaklands, with his wife, Sally (Baker); they had met while he was selling eggs. Education outside the home was first introduced through a subscription school, which students paid a fee to attend. By 1810, as a result of the "Poor Laws," the opportunity for all children to attend school had been introduced. In 1810, a list of 20 students needing tuition was submitted to the township, and by 1841, that number had grown to 43. In 1841, the township adopted a formal school system and, in 1941, consolidated its one-room neighborhood schoolhouses. (Photograph by the *Daily Local News*, courtesy of the Chester County Historical Commission, West Chester, Pennsylvania.)

Marty's Bar was located inside the Exton Lodge, on the southwest corner of Route 100 and Route 30. In 1939, Harold E. Martin purchased the property and built the Exton Lodge, which featured a restaurant, bar, and gas station. Martin paid children to count automobiles at the intersection to convince state officials in Harrisburg that a traffic light was needed. In fact, a Greyhound bus crashed into the lodge in the 1950s. Martin served as township supervisor, for which he is honored annually by the Exton Region Chamber of Commerce, which presents the Harold Martin Business Leadership Award to recipients who demonstrate leadership and an unselfish commitment to improving the quality of life in the Exton region. In the *Suburban Advertiser*'s December 18, 1986, article "A Collection of Best Wishes for the Holiday Season," Harold "Mr. Exton" Martin notes, "World peace would have to be number one overall. Locally, we need an Exton bypass, and to have our traffic circulation patterns corrected. Personally, I wish for good health and some peace and quiet." The Martin family ran the business for 40 years. (Courtesy of the Chester County Historical Commission, West Chester, Pennsylvania.)

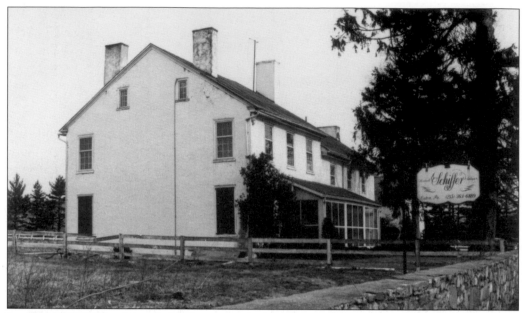

Located at 609 West Lincoln Highway, this building began as a two-room tenant house in the 1700s and grew to a sizable house after it was considerably expanded around 1825. John Roberts, who had inherited the property, realized that the location was perfect for a public house; thus, the Whiteland Inn operated here from 1827 to 1836.

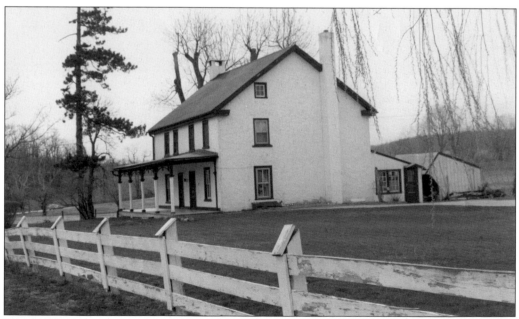

This building, constructed in 1765 and located at 613 Swedesford Road, was previously an inn. Named the Fox Chase Inn by John Quinn, the inn was the first licensed public house in West Whiteland Township. It served locals and weary travelers from 1786 to 1800.

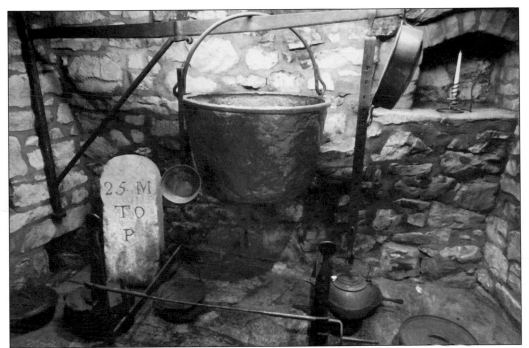

In the late 1790s, John Bowen built the Ship Inn located at the corner of Ship Road and Lincoln Highway. In 1794, the Lancaster Turnpike (Lincoln Highway) was constructed for stagecoaches traveling to and from Philadelphia. This photograph shows the original fireplace, which was used for cooking and keeping the tavern warm for the travelers. Also pictured is the only milestone to survive of the five markers that were installed in West Whiteland.

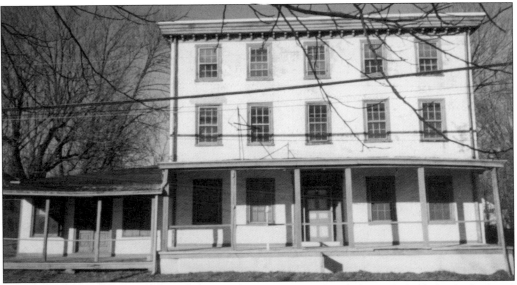

The Exton Hotel, built in 1859, is located at 423 East Lincoln Highway. J. Beale built the hotel to serve travelers on the Chester Valley Railroad and Lancaster Turnpike. Beale also served as the postmaster and ticket agent for the railroad. Beale repeatedly tried to obtain a liquor license, but was unsuccessful. Liquor eventually did make an appearance during Prohibition, as the hotel was known to be well supplied by bootleggers.

BIBLIOGRAPHY

Ewald, Johann; Joseph P. Tustin, trans, ed. *Diary of the American War: a Hessian Journal.* New Haven, CT: Yale University Press, 1979.

familytreemaker.com

Futhey, John Smith, and Gilbert Cope. *History of Chester County, Pennsylvania, with Genealogical and Biographical Sketches*, Philadelphia, PA: Louis H. Everts, 1881.

genealogy.com

Moir, Sean. *Technical Report of the Battle of the Clouds*, 2013.

Neighbour, Mary. *Vision and Ability: A History of CFS The Church Farm School.* Paoli, PA: CFS, The School at Church Farm.

Pusey, Nancy. *Transcribed Richard I. Downing's Letters.* West Chester, PA: Chester County Historical Society.

Snyder, Diane Sekura, and Martha Leigh Wolf. *A History of West Whiteland.* Exton, PA: West Whiteland Historical Commission, 1982.

Morrison, William. *The Mainline Country Houses 1870–1930.* New York: Acanthus Press, 2002.

nanticokelenapemuseum.org

New Jersey Historical Society. *Proceedings of the New Jersey Historical Society.* New Jersey, 1909.

theguernseycow.com

www.portal.state.pa.us

www.soldedadmansion.org

Zook (Mast), Louis Ann book at Lancaster Mennonite HC.

ABOUT THE ORGANIZATION

The West Whiteland Historical Commission is a volunteer board that works with the township staff and a board of supervisors to help limit negative impact on the township's historic resources. Along with attending monthly meetings, the commission works on special events, such as anniversary celebrations, participation in Chester County's Town Tours and Village Walks, and researching and documentation of historic properties. It is currently working to preserve, and find new use for, the township-owned Pennypacker House on Swedesford Road.

DISCOVER THOUSANDS OF LOCAL HISTORY BOOKS FEATURING MILLIONS OF VINTAGE IMAGES

Arcadia Publishing, the leading local history publisher in the United States, is committed to making history accessible and meaningful through publishing books that celebrate and preserve the heritage of America's people and places.

Find more books like this at
www.arcadiapublishing.com

Search for your hometown history, your old stomping grounds, and even your favorite sports team.

Consistent with our mission to preserve history on a local level, this book was printed in South Carolina on American-made paper and manufactured entirely in the United States. Products carrying the accredited Forest Stewardship Council (FSC) label are printed on 100 percent FSC-certified paper.

MADE IN THE